Learn to Paint

TREES

Norman Battershill

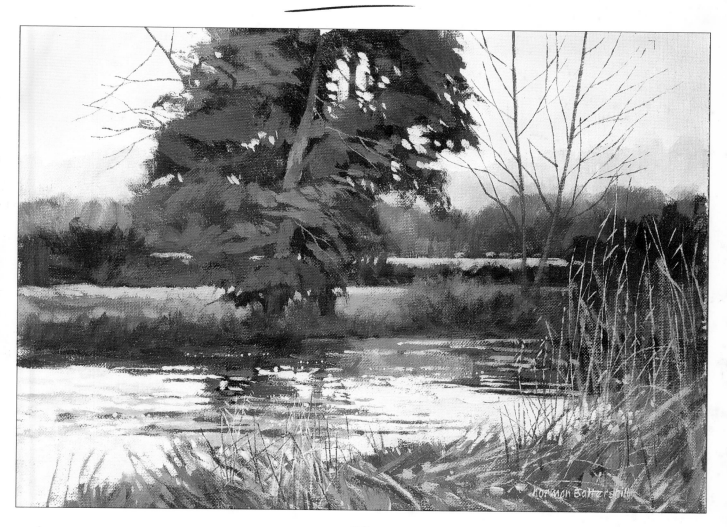

COLLINS

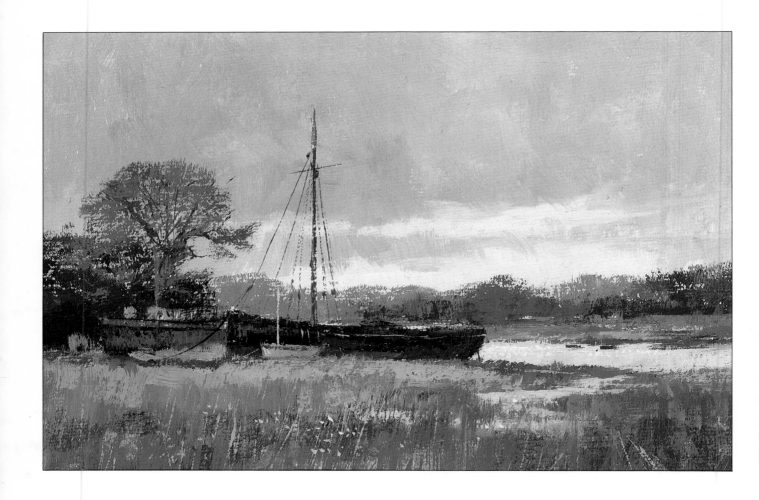

First published in 1990
by William Collins Sons & Co., Ltd
London · Glasgow · Sydney
Auckland · Toronto · Johannesburg

Reprinted 1990

© Norman Battershill 1990

Art Edited by Caroline Hill
Edited by Judith Warren
Designed by Kevin Shenton
Photography on pp. 4 & 5 by Martin Farquharson
Photography on pp. 10, 11, 12 & 13 by David Ridge
Filmset by Ace Filmsetting Ltd, Frome, Somerset

A CIP catalogue record for this book is available from
The British Library

ISBN 0 00 411554 6

Printed and bound in Hong Kong

CONTENTS

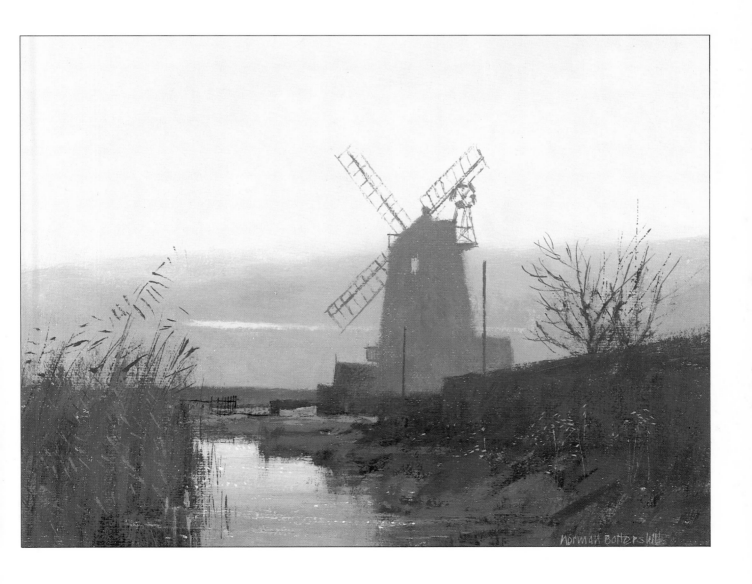

PORTRAIT OF AN ARTIST
NORMAN BATTERSHILL

Fig. 3 Norman Battershill in his studio

Norman Battershill lives in rural Dorset. He has a strong affinity for the countryside and is particularly interested in capturing a sense of atmosphere and mood in his paintings.

He started out as a designer, specializing in exhibition stands, displays and packaging for international companies. He travelled extensively to oversee the construction of his exhibition stands, to Paris, Stockholm, Hanover and other European cities, and was elected a Fellow of the Society of Industrial Artists and Designers in recognition of the distinction of his work. At this

time he also took on commissions for murals, both for companies and private houses; the largest mural he did, in oils, was 40×18 ft (12.20×5.49 m).

In his spare time he pursued his interest in painting. His work was seen in an exhibition by a publisher and Norman Battershill was asked to co-illustrate a book on archaeology. Further commissions to illustrate books and magazines followed. Eventually he decided to give up his design career and devote all his time to painting, acquiring a studio in the village of Steyning, Sussex. Since 1974, Norman Battershill has devoted all

4

Fig. 4 Norman Battershill painting near his home in Dorset

his time to painting and writing books and articles about painting. For many years he has been a regular contributor to *The Artist* and *Leisure Painter* magazines – and this is his twelfth book.

Norman Battershill is a very popular demonstrator at art societies and holds his own painting courses. He tutored the Pitman Correspondence Course in pastel for several years, and Southern Television have featured him painting on location. He broadcast a series of talks about learning to paint for Radio Brighton, which led to a great number of enquiries from listeners.

He has had many successful one-man shows; his paintings are in a large number of private collections, and are reproduced in limited edition prints and as greetings cards. In 1989 he received the ROI Stanley Grimm award from H.R.H. the Duchess of York. His commissions include drawings for Post Office stamp books, *Newsweek International* and paintings for Ricardo Engineering, the Beecham Group, CIBA GEIGY, British Gas Southern and the Post Office. He is a member of the Royal Society of British Artists, the Royal Institute of Oil Painters and the Pastel Society.

TREES AND THE LANDSCAPE PAINTER

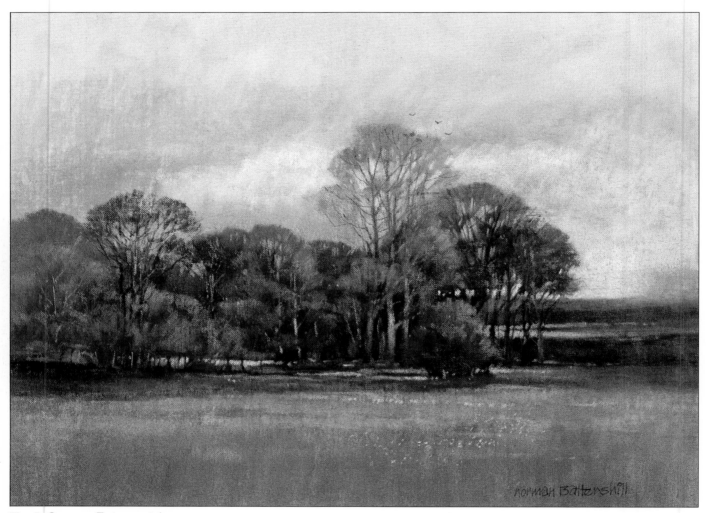

Fig. 5 *Summer Trees* pastel

For centuries artists have made a feature of trees in the many moods and styles of landscape painting. Among the masters of landscape are Turner, Constable, Cotman and the great French painter Corot. These and other artists of their time discarded the earlier formal treatment of trees in painting and went direct to nature for a truthful rendering. We cannot do better than to begin the study of trees as did those great artists. There is no substitute for drawing and painting trees outdoors, and in doing so you will discover a love and affinity for these beautiful living things which grace our streets, parks, gardens and countryside.

I am very fortunate to live in a rural and unspoilt part of Dorset, where there are many trees. Sometimes I

climb the hill behind my cottage and stand among the pines, listening to them whispering in the wind; from there I look down on the village towards the woods and the sea beyond. I cannot visualize this landscape without the presence of trees.

Painting trees well is one of the aims of all landscape painters, and successfully including them in a picture will give you a great sense of achievement and satisfaction. The effect to strive for is a sense of growth and naturalness of form (**fig. 5**) – not something stuck on top of the ground that looks as if it may topple over at any moment.

Although trees may form only a small part of a painting, they add a sense of growth and life, as well as con-

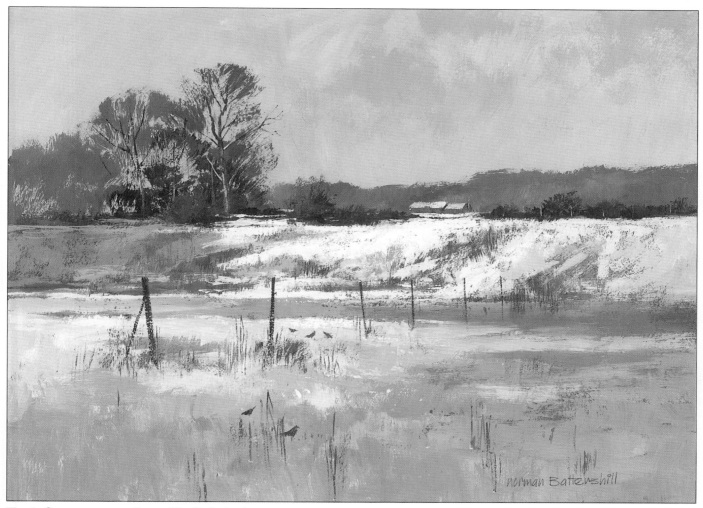

Fig. 6 *Snowscene* acrylic **Fig. 7** (below)

tributing to the mood and atmosphere of the work. My acrylic painting (**fig. 1** on title page verso) of an old barge at Chichester is a very simple subject; I have tried to convey a feeling of stillness and aerial atmosphere. Thames barges have a wonderful grace and are elegantly proportioned. Whenever I look at the main mast I think of the tree it was fashioned from. Perhaps it was for this reason, without realising it, that I included a tree on the left. You will notice that the shape of the tree contrasts with the straight mast and gives a rhythm to the subject, which is dominated by horizontals. Although the tree is secondary to the main subject I gave careful thought to its shape and placing. On the other side of the creek, low trees aid recession and help to give height to the mast. The Daler-Rowney colours I used were Burnt Sienna, Cadmium Red, Lemon Yellow, Ultramarine, Yellow Ochre and White.

Fig. 2 (the acrylic painting shown on the Contents page) was a challenge – I wanted to create a strongly atmospheric effect in a small picture. It is an imaginary subject painted in the studio, and the reason I have

included it is to show you another example of how just one tree can be important to a painting. Although the tree in my painting is a relatively minor addition it is there for several important reasons. If you cover it up,

7

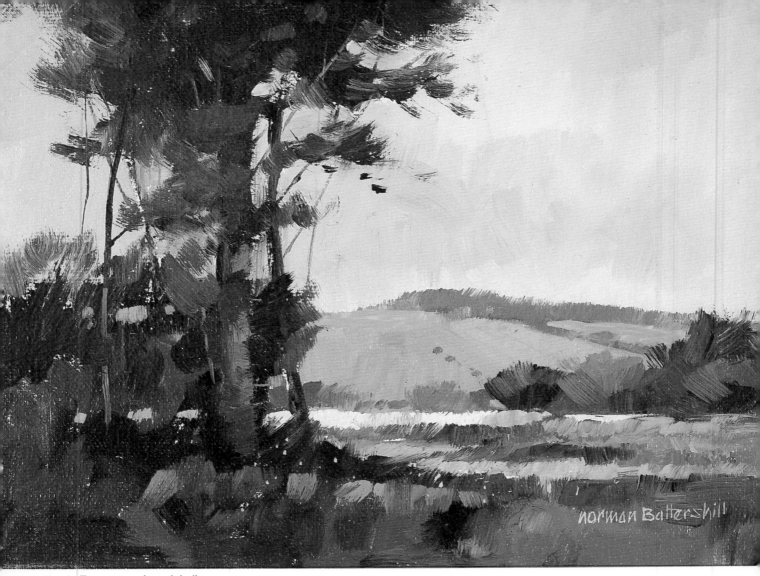

Fig. 8 *Trees near Arundel* oil

your interest goes straight to the windmill. But by including a tree on the right of the painting and tall reeds on the left, the windmill is subtly framed. The tree breaks up the rather forceful angle of the wall and gives recession to the mill. The Daler-Rowney colours I used were Cobalt Blue, Cadmium Red, Lemon Yellow, Cadmium Orange, Yellow Ochre, Burnt Sienna, Ultramarine and White.

I have said that the trees in both these paintings are secondary to the main feature, but making trees the wrong shape or colour can quite easily mar the success of a picture. I always carefully consider how and where I place trees in a landscape painting.

The importance of sketching

Drawing is a prelude to painting, and outdoor sketching has advantages which may not at first be apparent. It teaches you to 'see', not just to 'look' – there is a great difference between the two. As you gather knowledge and gain experience of your subject, even the slightest sketch may suggest an idea for a studio painting. Also you will begin to develop the ability to create the moods of nature when painting in the studio. Everything you see and experience registers in your memory. You will be able to recall such things as the soft silhouette of trees in the morning mist, the fall of rain on distant hills, the tracery of branches against a winter sky, or trees in the snow, dark against a pewter sky. Look at the work of the great landscape painters and notice how they use trees to convey an impression of weather.

My acrylic painting of a snow scene (**fig. 6**, on previous page) is an imaginary subject painted in the studio. I developed the idea from a photograph I took in the height of the summer. The snow-covered bank in the middle distance was really a grassy sunlit field, and the frozen stream a rutted cart track. As you gain experience, both your imagination and painting skills will develop and you will become much more aware of potential subjects. It obviously takes time to reach this stage, but you can get there if you try.

Learning the names of all the various species of tree

8

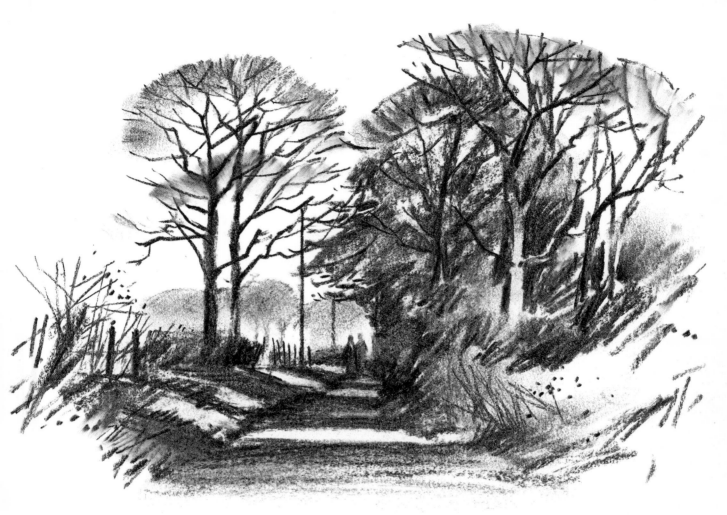

Fig. 9 *Dorset Lane* charcoal

is not really necessary, but to know some of them adds interest to your studies. It is much more important to be aware of the characteristics of different trees. Try to study them through the seasons. When I had my studio in Sussex I sketched or painted outdoors almost every day for three years. Poor weather did nothing to deter me – I worked in rain, snow and even fog. I still clearly recall the eerie effect of trees and grazing sheep appearing and vanishing in the swirling fog. One morning I drew trees in the snow and my legs were so numb with cold I fell over getting up from my painting stool! I am not suggesting you also suffer extremes in the cause of art, but try not to be put off by bad weather. A dedicated painter makes progress faster than a lazy one. The beauty and inherent energy of trees, their many shapes and changing colours, are an inspiration to the landscape painter. It is worth striving to paint them well and along the way you will without doubt acquire a lasting affection for trees, as I have.

I paint in all the traditional mediums, watercolour, oil, acrylics and pastels, and in this book I include some examples of each medium so that you can see the expressive qualities each has to offer. Of course you will not paint like me, for every artist has a personal style, but you might be encouraged to try a different medium for a change. And who knows, you may then change your course of direction, with unexpected benefit. I am not disguising the fact that painting trees is one of the most difficult subjects to tackle. This book will show you how to follow a number of established principles; it will help you to paint trees well and successfully include them in a landscape painting. It may also give you some encouragement to know I am a self-taught painter and any degree of success I enjoy is because I am dedicated to my painting. I am also continually learning from my observation of nature.

EQUIPMENT AND MATERIALS

The artist's supplies shop resembles an Aladdin's cave crammed with many exciting things. Selecting suitable materials and equipment from such a vast range can be rather daunting for a newcomer to painting, but you will find shop assistants helpful in your choice of artists' materials. A comprehensive illustrated catalogue of artists' materials and equipment is always useful – ask your local art shop or write direct to the suppliers. You probably will have to buy the catalogue but the expenditure is worthwhile. Depending on your pocket, artists' quality materials should be the first choice. The following recommendations are intended as a general guide.

Easels

For indoor use the radial easel is a popular choice. It takes up very little floor space, but will firmly hold a large canvas. A lightweight metal or wooden sketching easel is useful for outdoors – it can also be used indoors but does not have the same stability as the radial easel. A wooden table-top easel folds flat and is easy to store, but because it is small the size of picture it will support is rather limited. I use a French folding box easel for outdoor painting because it is so compact, but it can be rather heavy to carry over a distance when full with paints, so I limit what I put in it. I have had my box easel for more than twenty years and it has served me well for countless demonstrations and painting trips outdoors.

Drawing mediums

Lead pencils range from 8B, very soft, to 7H, very hard (**fig. 10**). A 2B pencil is sufficiently soft to give a range of tones from light to dark. The pencils I use are 2B, 4B, and 6B. I also like a soft carbon pencil because its marks do not shine in dark shaded areas like those of a lead pencil. Charcoal pencils and the pencils already mentioned are well worth trying out to familiarize yourself with all the various grades. Draw on different textured papers and note how the pencil makes distinctive marks.

Crayons An extensive range of colour pencils and colour sticks is available. The broader sticks encourage expressive marks. Artists and commercial art studios use this drawing medium to great advantage. I have included a few sketches in this book to show you examples of the lovely clear colours in the range.

Charcoal A charcoal stick (available in thick, medium or thin) is a beautiful and very expressive drawing medium. Capable of making a sensitive line or creating rapid areas of tone from black to the softest grey, charcoal is the most versatile of all drawing mediums. But a fixative must be used to prevent smudging. A number of my sketches in this book are charcoal; I normally use medium and thin sticks.

Paper The variety of paper available to the artist is too extensive to be listed here. Cartridge paper, suitable for most drawing mediums, is available in separate sheets or sketchbooks of various sizes. I recommend the Daler-Rowney spiral bound sketchbook sizes A4 and A5; the latter is small enough to slip into your pocket. Daler-Rowney also manufacture pastel and watercolour

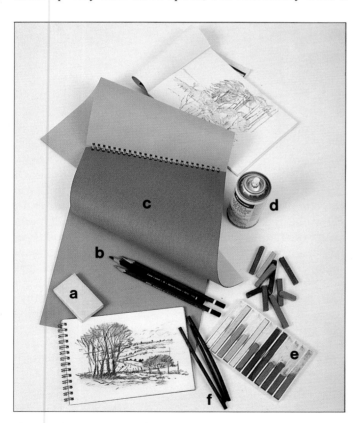

Fig. 10 Drawing materials
a putty rubber **b** lead pencils and soft carbon pencil
c Ingres pastel sketchpad **d** fixative
e crayons **f** charcoal

sketchbooks. Experimenting with different papers is fun and extends your means of self-expression.

Acrylics

The quick-drying properties of acrylics are an advantage when painting outdoors. Paintings can progress more speedily than when using oils, and yet similar techniques and results are possible. But once dry the paint cannot be scraped off or wiped out with a rag. Manufactured with pigments of the same quality as oil paints, acrylics are bound with a clear synthetic resin. Acrylics can be thinned with water and diluted to a transparent watercolour consistency; they may be applied with a painting knife for heavy impasto, or painted in the manner of oils. Acrylics can be applied to almost any surface providing it is free from grease or oil; canvas, hardboard and paper are the most common supports used, primed with acrylic primer. You can use synthetic brushes or oil colour brushes, but care must be taken to make sure that the paint does not harden on them. Because of its adhesive qualities, acrylic paint should not be used on a wooden palette – a plastic surface is preferable. I normally use the convenient tear-off disposable paper palettes for both acrylics and oils. Acrylics can be varnished with a spirit varnish, acrylic matt or gloss varnish.

There are two types of Daler-Rowney acrylic colour – Cryla, similar to oils in consistency, and Cryla Flow, which is thinner and has greater covering power. **Fig. 11** shows a range of acrylic paints and related equipment. If you have not tried acrylics before, I suggest you use standard Cryla. A Daler-Rowney acrylic starter set of a few colours will be enough to begin with. You can mix the colours on a white plate, and use just two or three synthetic brushes. As with all drawing or painting mediums, it takes time to get used to different properties so don't be put off if acrylics don't work for you straight away – be patient. If you have some experience with oils then painting in acrylics will not present many problems. I paint in all mediums, and find acrylics both versatile and easy to handle. Many of my paintings in this book are acrylics, so you can judge this delightful medium for yourself.

I use the same basic colours as those included in the Daler-Rowney introductory set of eight, although I don't use Black, which dulls colour. I use Payne's Grey instead. Some artists prefer to use Black, it is a matter of choice. I start with the following basic colours: Lemon Yellow, Yellow Ochre, Cadmium Yellow, Burnt Sienna, Ultramarine, Bright Green, Cadmium Red, Titanium White. I often supplement this list with Burnt Umber, Monestial Blue, Venetian Red, Cadmium Orange and Cobalt Blue.

Pastels

The only slight disadvantage of pastel is that it is dusty and your hands get grubby. But pastel is a versatile and wonderfully expressive medium. The Daler-Rowney Artists' Soft Pastels colour range is extensive, with over 200 beautiful tints and shades to choose from (see **fig. 12**). It is not necessary to buy a lot of pastels to begin with – a Daler-Rowney box of 12 or 24 pastels especially selected for landscape painting is enough for a starter set. (The largest box available has 144 assorted pastels.) As you become more experienced you can build up your stock by buying single pastels. I have about 250 assorted colours. Some artists use a pastel in its wrapper; others, myself included, break a piece off about half an inch long. This way I can use the side of the pastel to get a broad mark, which suits my style of pastel painting. Pastel pieces can be cleaned by shaking them in a flour sieve with some ground rice. The rice will fall through the tiny holes leaving clean and bright pieces of pastel.

Pastel marks do look different on coloured papers. White paper is not often used with pastels because it is too bright. I generally use pastels on a paper of neutral tint, such as light blue, mid-grey or brown. Dramatic effects can be achieved on dark blue, dark green, or

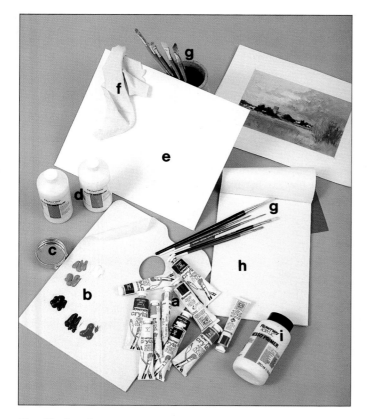

Fig. 11 Acrylics
a tubes of acrylic paint **b** paper tear-off palette
c single dipper **d** matt and gloss medium **e** hardboard
f painting rag **g** brushes **h** sketchpad **i** gesso primer

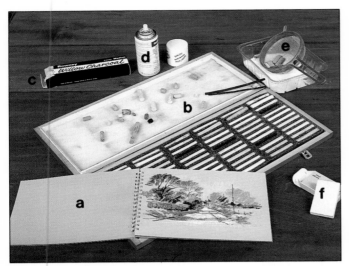

Fig. 12 Pastels
a Ingres pastel sketchpad **b** box of pastels **c** charcoal
d fixative **e** ground rice and flour sieve **f** putty rubber

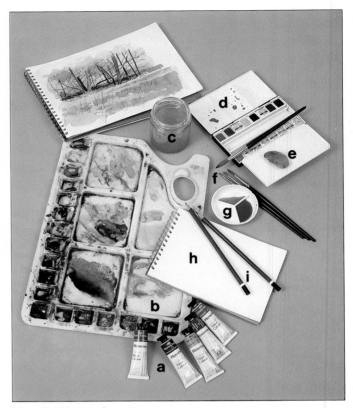

Fig. 13 Watercolour
a tubes of Artists' watercolour **b** watercolour palette **c** water
pot **d** watercolour paintbox **e** sponge **f** sable brushes
g mixing dish **h** watercolour pad **i** pencils

even black papers. Flour paper, sand paper, flock paper, velvet and pumice powder are other grounds which can be used, but to begin with keep to the more traditional pastel papers until you have gained some experience in handling the medium. Later on you can try pastel on watercolour paper, where a wash of watercolour or acrylic in a neutral tint will give an excellent base to work on. But the texture of the paper must not be too rough or the pastel marks will look very coarse. Pastels can easily be blended with the fingers or a piece of kitchen tissue, but too much blending weakens a painting.

Watercolour

The joy of watercolour lies in its lovely transparency and expressive fluidity. Ideal for outdoor and indoor painting, it is one of the most popular mediums. Watercolours are available in either tubes or pans – personally I prefer tubes. A box of Daler-Rowney half-pans or the introductory set of tubes is a good choice when starting out (see **fig. 13**). Artists' quality watercolours are expensive but this is justified by their clarity and brilliance. A little will go a long way! When you buy a watercolour palette make sure it has a thumbring or hole – very practical and easy to hold when painting outdoors. The basic watercolours I use are: Payne's Grey, Ultramarine, Cobalt Blue, Crimson Alizarin, Indigo, Cadmium Yellow, Cadmium Red, Burnt Sienna and Yellow Ochre. I only use a few of these at a time.

Watercolour paper is available in all sorts of sizes, qualities, weights and colours. The heavier the paper the less likely it is to buckle when wet. If you are not familiar with the range of papers it is best to choose a

'NOT' surface, rather than Hot Pressed which is the smoothest, or Rough which has a pronounced texture. The 'NOT' (cold pressed) has a fine texture and is in general use by a lot of watercolourists. An extensive range of watercolour sketchbooks and blocks is available; I suggest you start off with a 'NOT' surface 140 lb weight (300 gsm) Daler-Rowney Langton watercolour sketchbook. As you progress you can try out different textures and tints. Watercolour papers can also be bought in single sheets up to 30 × 22 in (762 × 599 mm). Daler-Rowney have a good selection. I use Langton and Bloxworth spiral bound sketchbooks a lot for outdoor sketches in watercolour.

A quality watercolour brush is a very expensive item, but will last you many years. I still use a red sable brush I bought fifteen years ago. Synthetic fibre brushes are economical to buy, but the natural product is preferable. To begin with, two or three sable brushes are quite enough; the size you choose will depend on the scale of your work and what you can afford. Numbers 10, 7 and 4 are suitable sizes for most work. Care of your brushes is essential. Make sure they are thoroughly washed in clean water and lay them flat to dry. If you put them end up in a jar with the bristle wet, the water will run down into the ferrule and may eventually rot the hairs.

Watercolour palettes can be bought in a range of sizes, in enamelled metal, plastic and ceramic. I generally use large plastic watercolour palettes for studio work; outdoors I use a folding palette watercolour box, or my watercolour field kit, designed by Alwyn Crawshaw.

Oils

You can begin oil painting with the minimum of equipment and materials (see **fig. 14**), and gradually build up as you go along. Watercolour paper is one of the cheapest supports to paint on. Prime it first with acrylic primer otherwise the oil in the paint may eventually rot the fibres. Hardboard is popular as a support, for it is cheap and has two different surfaces, one rough and the other smooth. I would recommend painting on the smooth side; again, prime it with acrylic primer and allow to dry for the recommended period. Canvas is favoured by the great majority of artists. Available in a wide range of textures, it can be bought by the metre and stretched over a stretcher, or bought on stretchers. Canvas covered boards and oil sketching paper in all sizes can be bought from your art shop. A manageable size when you begin oil painting is 14 × 12 in (355 × 254 mm). Choose a medium surface canvas rather than a coarse textured one.

Daler-Rowney oils come in two grades, Artists' quality and Georgian. Artists' quality are better if you can afford these, but Georgian are cheaper. A Daler-Rowney starter set of boxed colours has sufficient range to give ample scope for colour mixing. These sets consist of the same colours I use as my basic range: Burnt Sienna, Yellow Ochre, Ultramarine, Cadmium Red, Crimson Alazarin, Lemon Yellow, Raw Umber, Cobalt Blue and Titanium White.

Plastic and wooden palettes come in a variety of shapes and sizes. For studio work I have a 24 in (610 mm) solid mahogany palette. I also use A4 (297 × 210 mm) tear-off paper palettes. Outdoors I use either the convenient paper tear-off type or an oblong wooden one from my paint box.

The range of oil colour brushes is extensive; you may like to try Daler-Rowney Bristlewhite Long Flat Hog Brushes, series B48 (**fig. 14**). Short brushes have a tendency to accumulate a lot of paint at the end of the ferrule. Brushmarks will differ with the shape of the bristle – short bristles give strong stroke definition, whereas the longer bristle holds more paint and gives a longer, more fluid stroke. Good quality brushes retain their shape if you look after them. Always keep them clean by rinsing in turpentine and wash afterwards with soap and water. Taking care of your brushes helps to prolong their life and they will be a pleasure to use when in good condition.

To enhance the flow of oil colours and improve the

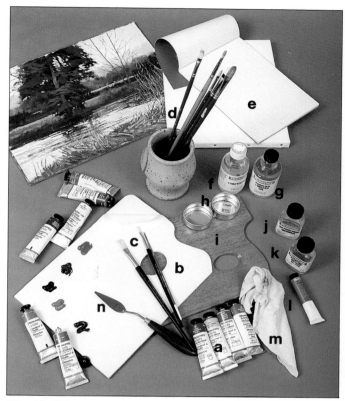

Fig. 14 Oils
a tubes of Artists' oil colours
b paper tear-off palette **c** brushes **d** canvas
e oil sketchpad **f** turpentine **g** linseed oil
h double dipper **i** rectangular wooden palette
j retouching varnish **k** painting medium
l gel medium **m** painting rag **n** painting knife

rate at which they dry, a painting medium can be mixed in small quantities. Try using a dipper clipped to the palette. Linseed oil can also be used instead of a medium, but adding too much to paint may eventually cause it to yellow and crack. Daler-Rowney have very informative literature on their range of oils, dilutents, painting mediums and oil varnishes. Gel medium is used by artists for reducing the drying time and for producing clear glazes, and I find this particularly useful for outdoor work as I can develop a painting much more quickly if the drying process is hastened. Read all you can to familiarize yourself with the properties of the products I have mentioned, and then experiment with one or two. I suggest you first try both the painting medium and gel medium. Mix a little with a patch of colour and note the time the surface takes to get tacky.

DRAWING TREES

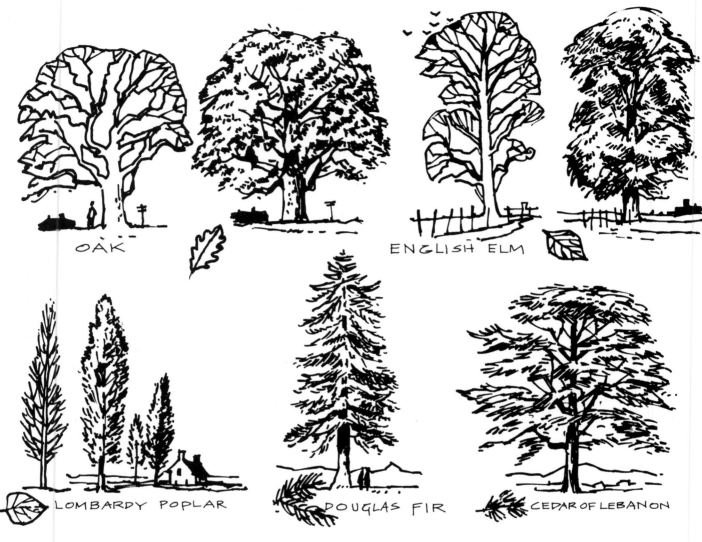

OAK

ENGLISH ELM

LOMBARDY POPLAR

DOUGLAS FIR

CEDAR OF LEBANON

Fig. 15

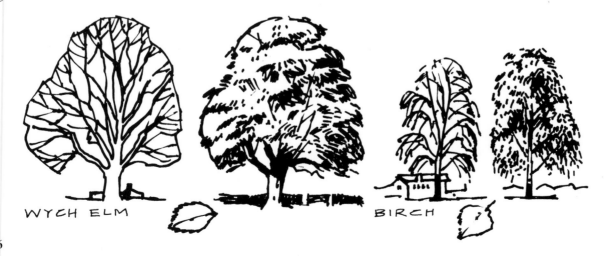

WYCH ELM

BIRCH

Fig. 16

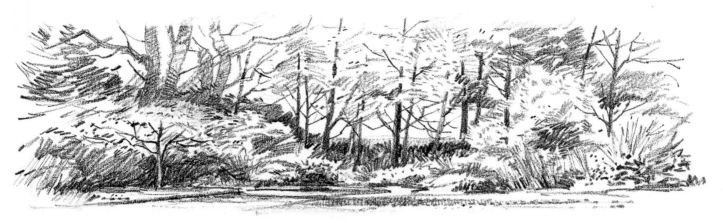

Fig. 17 *Wooded Landscape* soft pencil

The best time to begin your study of trees is in winter when deciduous trees have shed their leaves and the structure of trunk and branch is visible. The character of a tree is defined by its overall shape; you can see how they differ by my simplified basic drawings of trees in winter and also summer (**figs. 15 and 16**). Start your first drawings of trees by selecting one, and sketch it from a distance so that you can see all of its shape. Sitting down is more comfortable than standing for sketching, and make sure you are warmly wrapped against the cold. You can fill a sketchbook with single tree studies and then move on to drawing groups of trees. Remember to simplify what you see by drawing only the main parts of the structure. As you gain confidence you can add more detail, but be careful not to overdo it or you may lose the character of the tree. Keep your drawings to a manageable size – several drawings on an A4 page is about right to begin with. Use a 2B pencil and start your preliminary drawing lightly; as you gain confi-

dence you will find your pencil marks become bolder and more certain.

By all means supplement your outdoor sketches with photographs if you wish, but there are pitfalls to be avoided, discussed in more detail later on in the section 'Working from Photographs'. Remember, it is always better to work directly from nature. There are no short cuts. Drawing trees is much more daunting than painting them, for the point of a pencil seems an inadequate way of portraying such complex subjects, but if you persevere you will certainly make progress. When you sketch trees, remember you are not trying to make your drawing a photographic likeness, but are aiming for an artist's impression (**fig. 17**). After you have been drawing trees for a while in pencil, you may like to change to charcoal (**fig. 18**). Experiment with different drawing mediums and various grades of pencil, as by doing this you may find one that enables you to better express yourself.

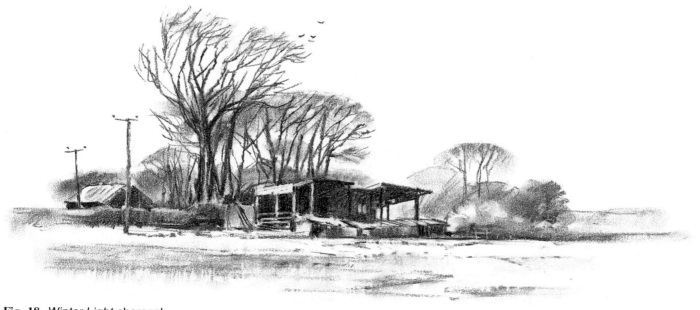

Fig. 18 *Winter Light* charcoal

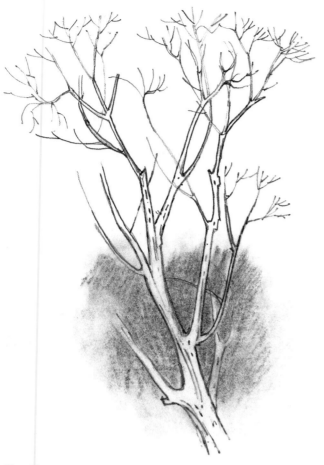

Fig. 19

It is often incorrectly assumed that the twigs and branches of trees taper. This is a common mistake, and the result of a lack of observation. Each branch extends another branch which is smaller in diameter and this in turn sends out a twig smaller in diameter, and so on, until smaller twigs at the outermost tip are reached. If you look closely you will find that branches become smaller in diameter at irregular stages – they do not taper in a carefully progressed, drawn-out way. Remember this when sketching trees. My sketch of a small piece of twig (**fig. 19**) illustrates the growth of a tree. The twig was no more than six inches in length. With the aid of an illustrated identification guide to trees which you can slip into your pocket or painting satchel, try to identify the tree you are sketching and make a note of it, together with the time of day and date. By making a series of studies of one variety of tree (the oak, for example) you will soon have a thorough knowledge of its structure and foliage. This will help you later on when you come to include trees in the landscape, for you painting will have a convincing naturalness. It is important to convey the height of trees, so look for nearby barns, fences or dwellings which can be incorporated into your subject. A quick glance through this book will show you how I have achieved a sense of scale in my paintings and sketches by including something which can be compared with the breadth and height of the trees.

Studying branches

A small branch is similar in structure and growth to a tree, the secondary growth stemming from the main part and then sub-dividing (**fig. 20**). To understand this fully, choose a small branch with lots of growth stemming from it and make a careful drawing. If you want to avoid too many problems with foreshortening, place the branch horizontally at about eye-level when you are sitting down. Place a white sheet of paper behind the branch so that it is shown to advantage. At this stage keep to outline drawing only, you can shade in your studies later on.

Another interesting exercise concerns the flow and pattern of branch and twig. Paint the branch you already have with white emulsion and place it against a background of coloured poster paper. Draw it carefully and look for both the outline and the shapes created inside as I have illustrated in **fig. 20**. Keep your drawing simple and concentrate on the patterns. The shapes of branch and tree trunks are not perfectly cylindrical but have subtle variations of form, revealed in the contour drawings shown in **fig. 21**. Make a number of studies from a branch following the contours carefully and looking for the changes of shape and direction. By the way, when you have completed an exercise put the date on it and keep it safely for reference purposes; never destroy any of your work, no matter how poor it may seem to you. All your studies are important and mark your progress.

Using shading for texture

So far you have been drawing in line, but now we must consider how to use shading to show texture and the contrast of light and dark. The complexity of trees in full foliage makes them daunting subjects to draw, but by half closing your eyes the half tones are eliminated and the mass of leaves is simplified into defined contrasts. Although you are only indicating the shaded parts, you can see from my pencil drawing of an oak and Scots pine (**fig. 22**) the differences between the tree trunks and the foliage of the various trees. You can also see from these sketches that foliage does not create a solid mass; there are spaces, through which birds can fly. Sometimes the shape of a tree is better from one viewpoint than another, so before you settle down to draw, view it from several angles. Branches inclined towards you are difficult to portray because of the problems of foreshortening, so until you gain more experience a view from another angle may be simpler.

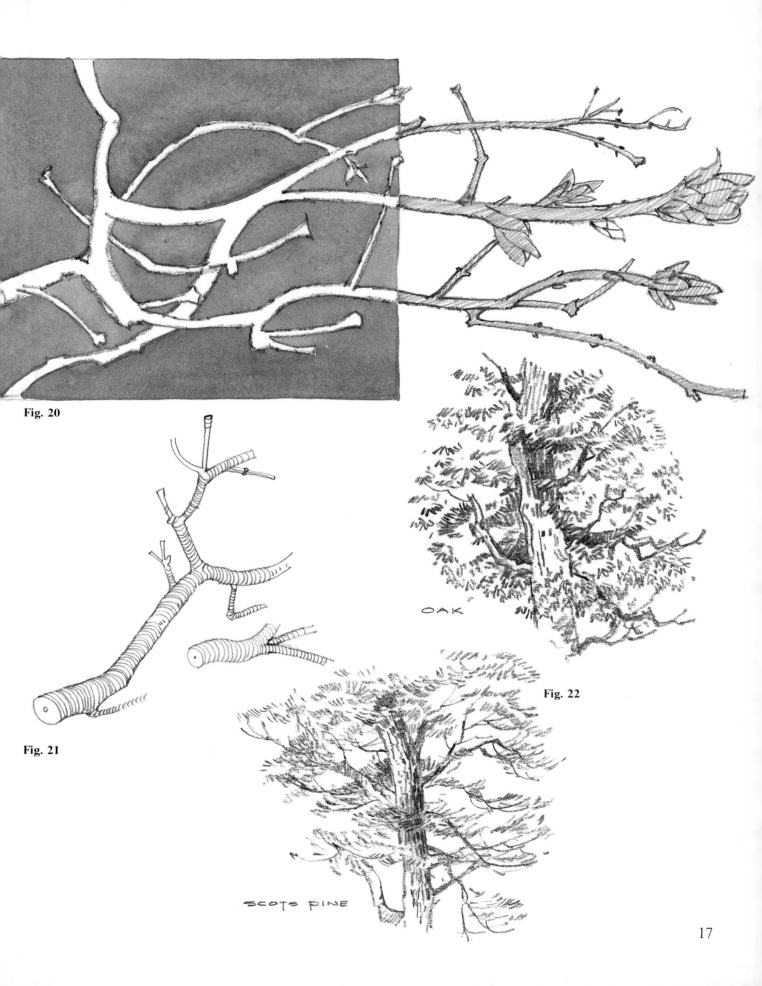

Fig. 20

Fig. 21

Fig. 22

OAK

SCOTS PINE

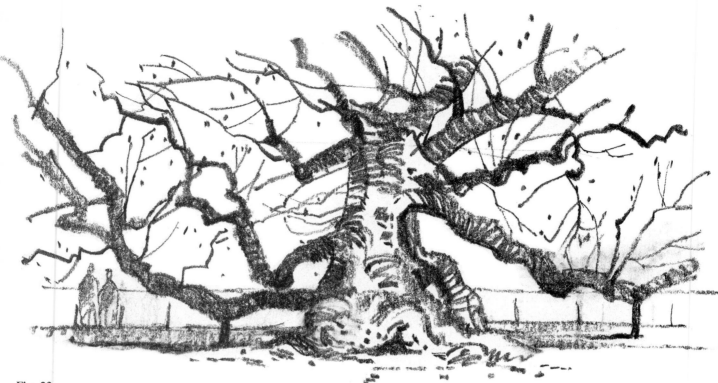

Fig. 23

The effect of lighting on trees is an important means of creating interest in a painting or drawing. Side lighting shows the shape of a tree to advantage, as the contrast of light and shade defines both the roundness of the overall mass of foliage and the quality of its leaf texture. It may help you to imagine the overall shape of a tree in leaf as a cone or a ball, which will give you a feeling of roundness – but this mustn't be taken too literally, of course!

Your sketches of trees should not be confined to drawing from a distance. As you become more proficient and understand the structure and form of trees, you can start drawing close to the lower part of a tree. As ever, keep your sketches simple and try not to overload the detail. This distorted tree (**fig. 23**) is the biggest ash in Great Britain and is reputed to be more than 200 years old. Its girth is 23 ft (*c.* 7 m). The huge lower branches have to be supported on posts. In my pencil sketch I have endeavoured to capture the rugged growth with vigorous pencil marks. I have added the

figures to give scale to this magnificent, ancient giant.

The distant wood shown in **fig. 24** is the view from the end of my garden, which I have included to show you a method of depicting a mass of foliage seen from a distance.

The page of pencil drawings opposite (**fig. 25**) gives some examples of the characteristic leaf forms of different trees. Before you begin to do similar drawings, experiment with pencil marks on a separate piece of paper to determine which marks create the right effect for a particular sort of foliage. I have simplified my drawings by deleting a lot of leaves.

In the drawing of an apple tree, you can see the characteristic curve of the leaves. I have shown the density of the holly's thorny growth. The young feathery shape of the *chamaecyparis* is typical of this soft young golden conifer. I have drawn a very small part of a magnificent horse chestnut tree, just down the lane from our cottage. Only a few of the lovely candle-like flowers remained after a long hot spell in May.

Fig. 24

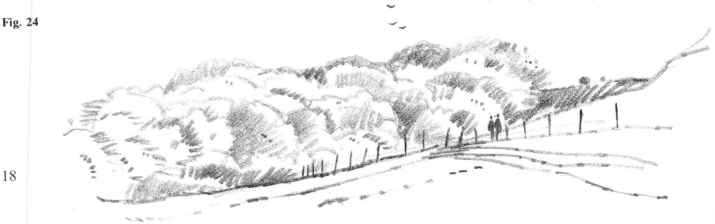

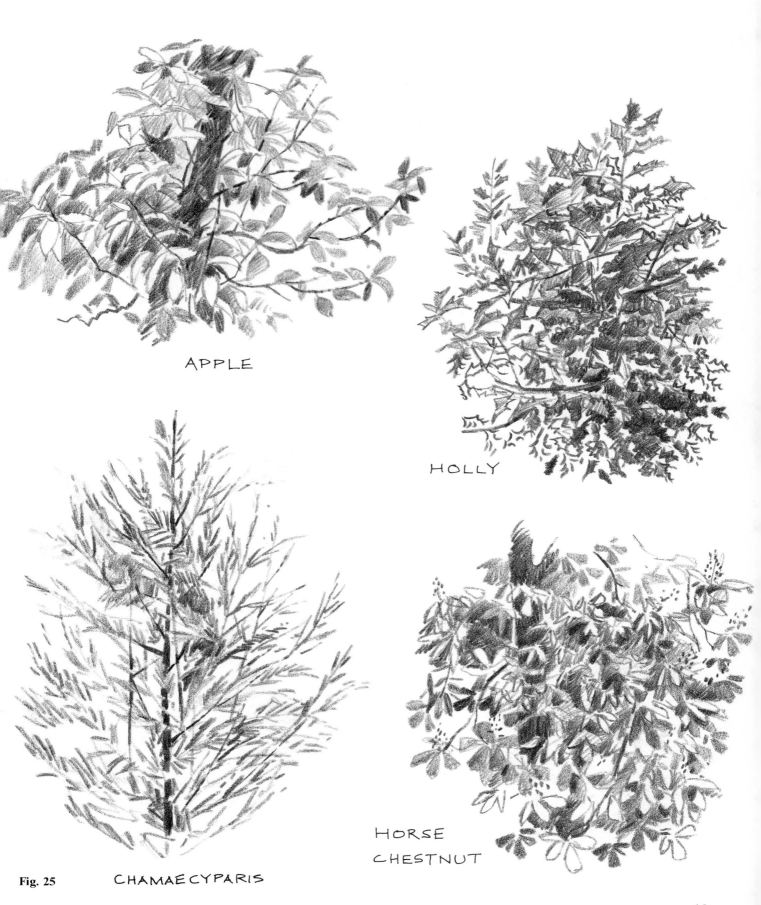

APPLE

HOLLY

CHAMAECYPARIS

HORSE
CHESTNUT

Fig. 25

SKETCHING OUTDOORS: COMPOSITION

We are now ready to go outdoors and include trees in a landscape. The subject will depend on what is near you – perhaps you can work in a park or garden if you are not near to countryside. Nature has all the elements for you to make a picture, but frequently the artist has to arrange what he sees into a more balanced composition.

Selecting a subject that is not too complicated will give you confidence, and a viewfinder might help you here. It can be made by cutting a rectangle of approximately 3 × 1½ in (76 × 38 mm) out of a piece of stout grey card. I carry mine in a sketchbook so that it won't get buckled. By moving the viewfinder you can find several interesting areas from just one subject.

Basically, composition is an arrangement of various parts assembled to make a harmonious whole. I expect you have seen pictures which look unbalanced because parts of them seem out of place. To show you some common faults I have illustrated mistakes which often occur in students' work. There are two problems in **fig. 26**: the tree is right in the middle and divides the picture area into two equal parts; there is also a 'fringe' or what I call a 'pelmet' along the bottom edge, which creates unnecessary emphasis. Another frequent error in composition is shown in **fig. 27**, where the tree is tight against the edge. The two trees in **fig. 28** create an empty space between them – this effect is often called 'book-ends'. Anything angled towards a corner is like an arrow and leads interest right out of the picture (**fig. 29**). These are simple faults that can spoil a nice painting. A very good test to see if a composition is balanced or not is to look at it in a mirror. Many professional artists use this method to check their paintings for composition errors.

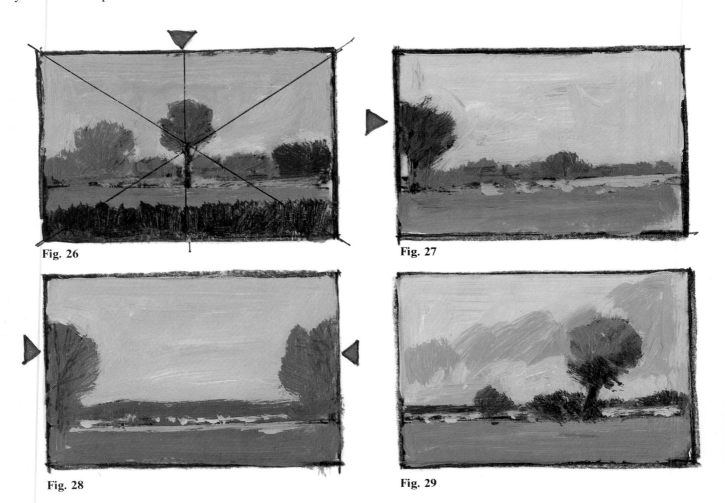

Fig. 26

Fig. 27

Fig. 28

Fig. 29

Fig. 30

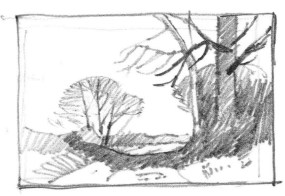

Fig. 31

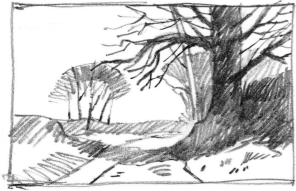

Fig. 32

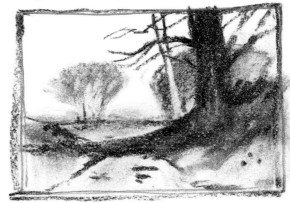

Fig. 33

Looking for a subject

Before you go out on your sketching trip make sure you have everything you need. I carry all my gear in a fisherman's bag, making sure my pencils are in a box to protect the points. To sharpen them I use a small craft knife with a retractable blade for safety. An elastic band around the sketchbook prevents the pages smudging together in transit; a putty rubber and comfortable lightweight sketching stool completes the kit. Choosing a subject is not always easy. If you see a view that attracts your interest don't ignore it and walk on hoping there will be a better subject somewhere else. More than likely you will keep on walking and eventually return to the spot you first saw, too tired to do anything! Isolating part of a view to create an interesting composition is not easy for the student. Look at the scene through your viewfinder, moving it backwards and forwards and from side to side, until your selected view presents a balanced arrangement. Remember where the main elements are and sketch their relative positions lightly on your sketch pad. **Fig. 30** illustrates how you can isolate part of a view and make a sketch of it; yours need be no bigger than the sketches shown here. When you have lightly drawn in your subject, half close your eyes and shade in the main areas of dark as I have shown in **fig. 31**. Ignore the temptation to add

detail until the final stage (**fig. 32**), but be careful not to overdo it, or your sketch will look fussy. For these illustrations I used a 2B pencil, but my last sketch (**fig. 33**) is charcoal, included to show you how charcoal can be used for small sketches. For outdoor sketching I often use a 6B pencil, as the range of tone from light to dark is ideal for expressing light and shade. Be careful not to press too hard when shading the dark parts because the soft lead produces an unpleasant shine.

I would like you to imagine we are going out sketching together so that I can demonstrate some compositional problems we are certain to encounter, and show you ways to overcome them. You can look over my shoulder as I sketch. I shall use my photographs as if we are actually outdoors looking at the subject. Wareham is an interesting old town in Dorset on the banks of the River Frome; we will park the car by the bridge and walk along the riverside path towards the yacht club. The day is fine but without any strong contrasts of light and shade. Our first interesting view is across the meadows to the distant wooded hills (**fig. 34**, overleaf). If you refer back to **fig. 26** I illustrated a common fault, where a 'fringe' is found at the bottom of the picture; here in front of us the foreground reeds create exactly the same effect, so we will delete them. You probably have also noticed the gap between the two parts of the hilltop wood is very pronounced. It might

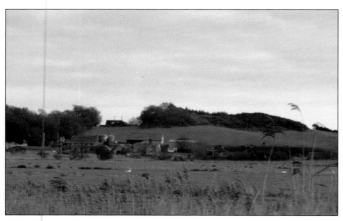

Fig. 34

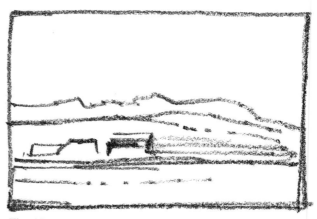

Fig. 35

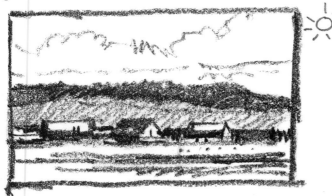

Fig. 36

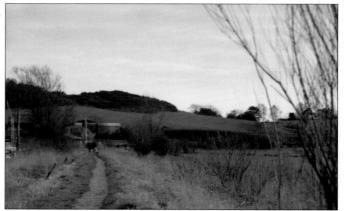

Fig. 37

Fig. 38

be better to extend the wood to close the gap. I will make a preliminary sketch to try out an alternative composition (**fig. 35**); this arrangement is much better, for the composition is now balanced. In our final sketch (**fig. 36**) the direction of the sun is shown by shadows on the farm buildings and meadows. The sky is slightly overcast so we must either emphasize the contrast of light and shade, or indicate the direction of the sun; this will be useful for reference when you come to paint a picture later on in the studio.

At the end of the riverside walk there is an interesting group of farm buildings and we may find some worthwhile subjects there. As we get closer the path and bank of reeds sweep round to the buildings (**fig. 37**) and create an interesting composition. Notice how much better it is without the gap seen in **fig. 34**. Let us stop here and make a sketch, making sure not to obstruct the public pathway. Again, there is a composition problem, in that the tree on the right is on the edge of the picture. By moving it the composition becomes balanced (**fig. 38**). Notice how two distant figures give scale and distance to the trees on the left. A sense of scale is very important in landscape painting.

It is getting late and we ought to be getting back to the car, but there may be an opportunity for one last sketch. As we go around the last corner there is a splendid view of Wareham Church (**fig. 39**), well worth drawing. The tree on the right is stuck on the edge so must be moved into the picture. **Fig. 40** shows an improved composition. I have lowered the horizon to give greater emphasis to the sky. After a well-deserved cream tea in Wareham it is time to leave this delightful part of Dorset – and I am sure you have learnt a lot about basic composition from our walk together.

Back in the studio later, I looked through the sketches and photographs and decided to make an

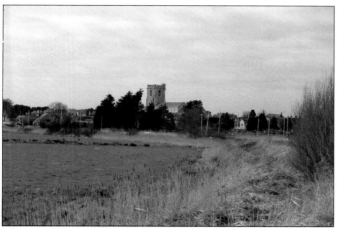

Fig. 39

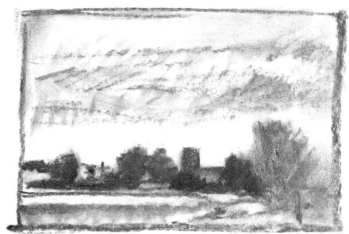

Fig. 40

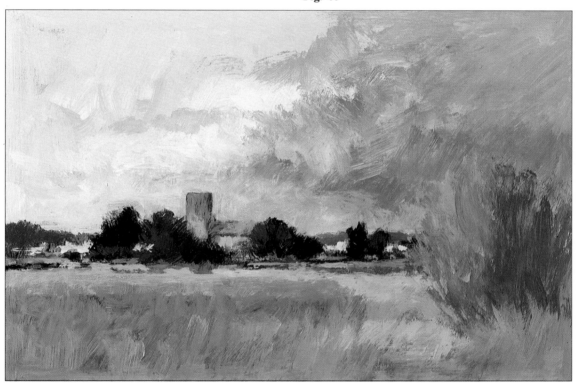

Fig. 41 *Wareham from the Fields* acrylic

acrylic painting from the photograph (**fig. 39**) and my charcoal sketch of Wareham Church (**fig. 40**). You can see that I have modified the shape of the evergreen trees in front of the church to create a soft rounded shape; in the photograph they lean towards the church at an acute angle. The reeds in the foreground are too dominant for my painting, so I have suggested only a few. The shrub on the right is too close to the edge of the photograph – in my painting (**fig. 41**) I moved it and have given it a more rounded shape. The dark trees are very important because they form a strong contrast against the church and within the rest of the painting. You may prefer to make an accurate representation of the view, but for my picture I wanted to create a sense of space and open air, so I have painted an impression of what I actually saw, using the charcoal sketch and the photograph as a reference. The Daler-Rowney acrylic colours I used were Lemon Yellow, Bright Green, Monestial Blue, Cadmium Red, Burnt Sienna, Yellow Ochre and White. To achieve a broad effect, I used just one brush – a very well worn oil colour bristle brush, No. 4, whose bristles have worn to a pointed shape. Don't throw your old brushes away – you can use them to create specific effects in your painting, as I have done. The broad effect in the sky here adds vigour. It is on thin card, and measures 8¾ × 6 in (222 × 152 mm).

23

STARTING WITH COLOUR

Nature has an enviable way of making the greens in the landscape completely harmonious. The artist, however, often has problems in producing a comparable harmony, particularly when painting trees in full summer foliage.

Colour mixing should not be hurried or haphazard. It is better to start off with perhaps four or five colours on your palette than confuse yourself with too many – a lot of colours mixed together invariably result in a muddy grey. As you progress more colours can be added to your palette. Don't be afraid to experiment; try different combinations of colours and make a note of them on a scrap of paper for future reference.

Learning about colour indoors before painting outdoors saves a lot of frustration later on. Painting house plants is a very good way of finding out how to mix a variety of greens. Some plants have growth similar in appearance to that of trees.

Almost all nature's greens have an element of red in them. This is one of the principal keys to harmonious colour mixing. Adding red to green modifies it, and makes a subtle and warmer colour. But you need not be confined to using the obvious Cadmium Red or Crimson. Any warm colour will suffice – **fig. 44** is an example of how acrylic Bright Green can be subdued by adding Burnt Umber, Burnt Sienna, Crimson, Cadmium Yellow or Raw Umber. When you mix green from yellow and blue, a touch of any of these colours will change it. My colour chart shows only a few alternatives, so try other warm colours too.

An extensive range of greens can be mixed by simply changing the basic colours used. There are several different blues and yellows to experiment with – look at **fig. 45** opposite. Add white and Payne's Grey in varying quantities to any green and you have a limitless range of tints and shades. **Fig. 44** also shows you how acrylic Bright Green can be changed to more subtle colours. Copy these colour charts and keep them for reference. Remember that too much white makes colour chalky. I often keep a colour swatch of a colour mix that I like, as remembering at a later date what colours you used is not always easy.

For my acrylic sketch (**fig. 42**) I have used only three colours and white – Monestial Blue, Cadmium Red and Cadmium Yellow Pale. Monestial Blue is a powerful colour and should be used sparingly – even a small amount is sufficient when mixing colours. A brilliant green can be mixed from Monestial Blue and Cadmium Yellow Pale. Add Cadmium Red to reduce this bright green to a more subtle colour. I used one Daler-Rowney brush, B48, size 3, and a No. 2 rigger. The sketch is on cartridge paper.

My watercolour sketch (**fig. 43**) is on cartridge paper, and the colours are Venetian Red, Ultramarine, Cadmium Yellow and Payne's Grey. I used one brush which created a broad effect, a Daler-Rowney No. 6. Venetian Red is a strong colour and must be used carefully. Payne's Grey and Cadmium Yellow make a subtle green if the Payne's Grey is used in moderation, as it was in this sketch.

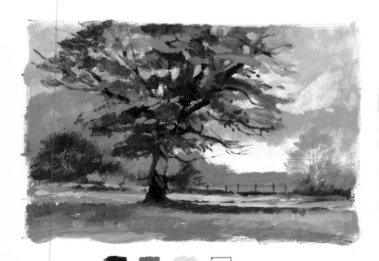

Fig. 42

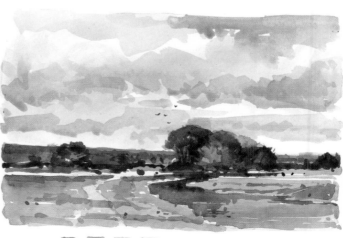

Fig. 43

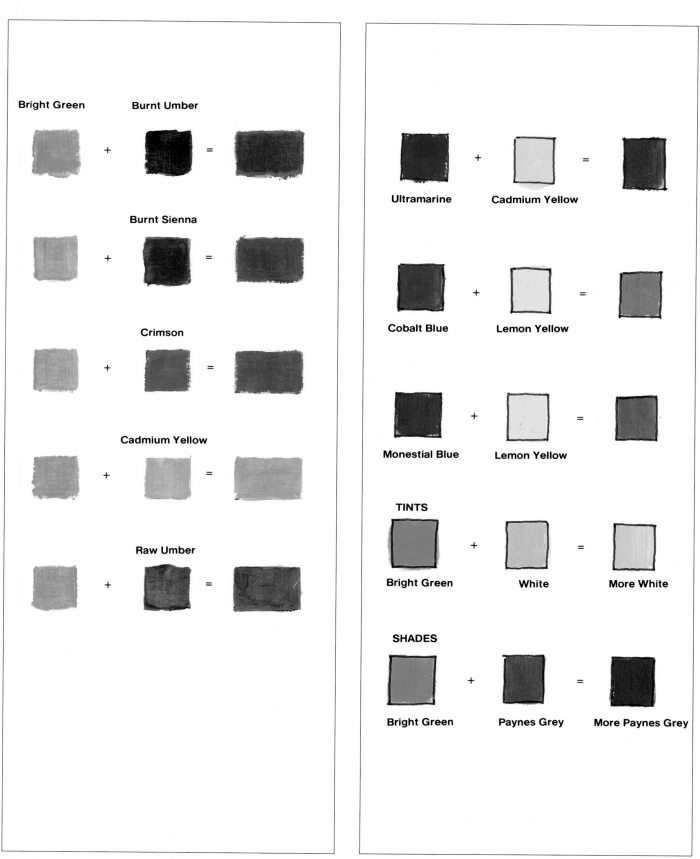

Bright Green + **Burnt Umber** =

Burnt Sienna =

Crimson =

Cadmium Yellow =

Raw Umber =

Ultramarine + **Cadmium Yellow** =

Cobalt Blue + **Lemon Yellow** =

Monestial Blue + **Lemon Yellow** =

TINTS

Bright Green + **White** = **More White**

SHADES

Bright Green + **Paynes Grey** = **More Paynes Grey**

Fig. 44

Fig. 45

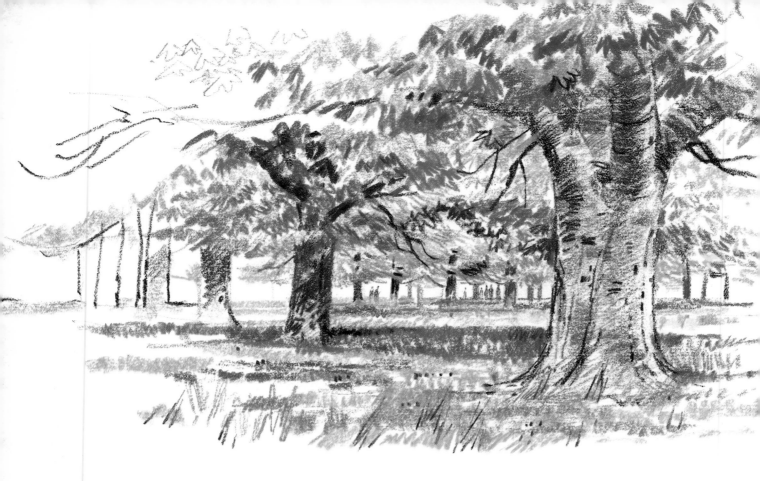

Fig. 46 *Park Scene* crayon

Mixing colours

When you mix colours, try to keep them fresh by not working one into another too much on your painting. The ideal is to mix the right colour on your palette, put it on your picture and leave it alone. Brushmarks are important to the appearance of a painting, and visible marks add vigour and movement. (Think of Van Gogh's paintings, for example, though of course that may not be your own style.)

To appreciate the value of colour freshness I suggest you try a few sketches with crayons or colour pencils. I have not made much use of crayons in the past, but I tried them out for **fig. 46**; as you can see the colours were clean and bright and I found the crayons exciting to use. The left hand side is unfinished to show you how I began. Notice how the foliage is not shown in detail but only suggested. I looked for the character and general shape of the foliage and then gave my impression of it. The colours I used are shown underneath.

I would like to mention that there is a difference between printing inks and paints, so the colour swatches reproduced in the book may not be absolutely true to the colours I used, though they have been as closely matched as possible.

Using one colour is particularly useful for making simple sketches; my watercolour (**fig. 47**) is on cartridge paper and I used diluted Payne's Grey. I have not used any white paint at all. For tree studies painting in monochrome is helpful because you can then concern yourself with the light and dark tones of colour and the contrasts these create, not the actual colour itself. For my tree study in acrylics (**fig. 48**) I have used Bright Green, Payne's Grey and White; by adding increasing quantities of white to the trees I have created a sense of recession.

Painting tree trunks

If I ask you what colour tree trunks are you are more than likely to say 'brown'. Their colour, however, is seldom just brown. The type of tree, its location and age have to be taken into account. Invariably, too, there is a lovely patina brought about by long exposure to weather, which may vary from brown/grey to silver/green/grey. Make a note of the different trunks that you

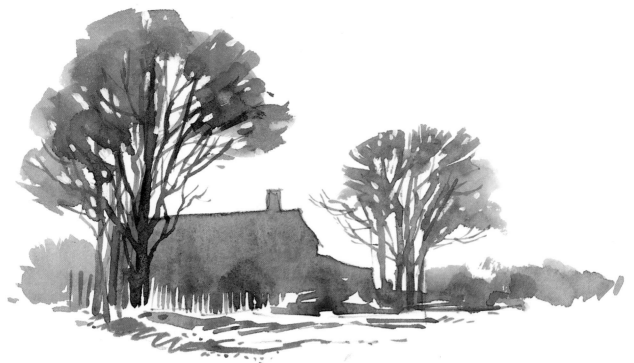

Fig. 47

see; you will be quite surprised at the variations in colour. Also, try not to take colour *too* literally – analyse it carefully. Winter trees may appear to be black when seen from a distance, but to use black straight from the tube is unimaginative and the result will be dull. To achieve a more interesting colour you could try several colour combinations: Ultramarine and Crimson Alizarin, Payne's Grey and Cadmium Red, Burnt Sienna and Yellow Ochre.

Study the texture of various tree trunks; put your hand on the bark to feel the surface. If you are doing a close-up study decide how best you can paint it to show the texture – experiment on a separate piece of paper or board before deciding which technique is most suitable. If you are painting in acrylics or oils make your brushstrokes follow the shape of the trunk. While you are painting the trunk, observe how it spreads out at its base. The trees in your painting should look as if they

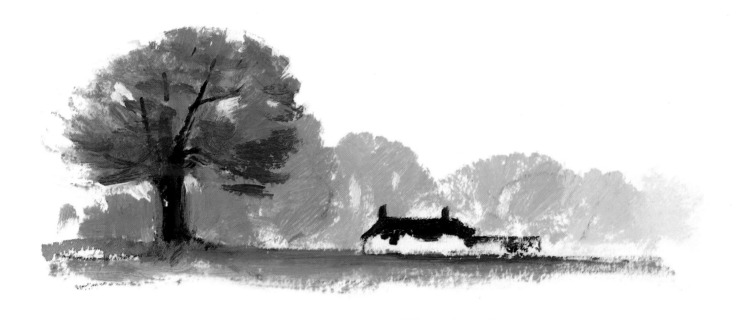

Fig. 48

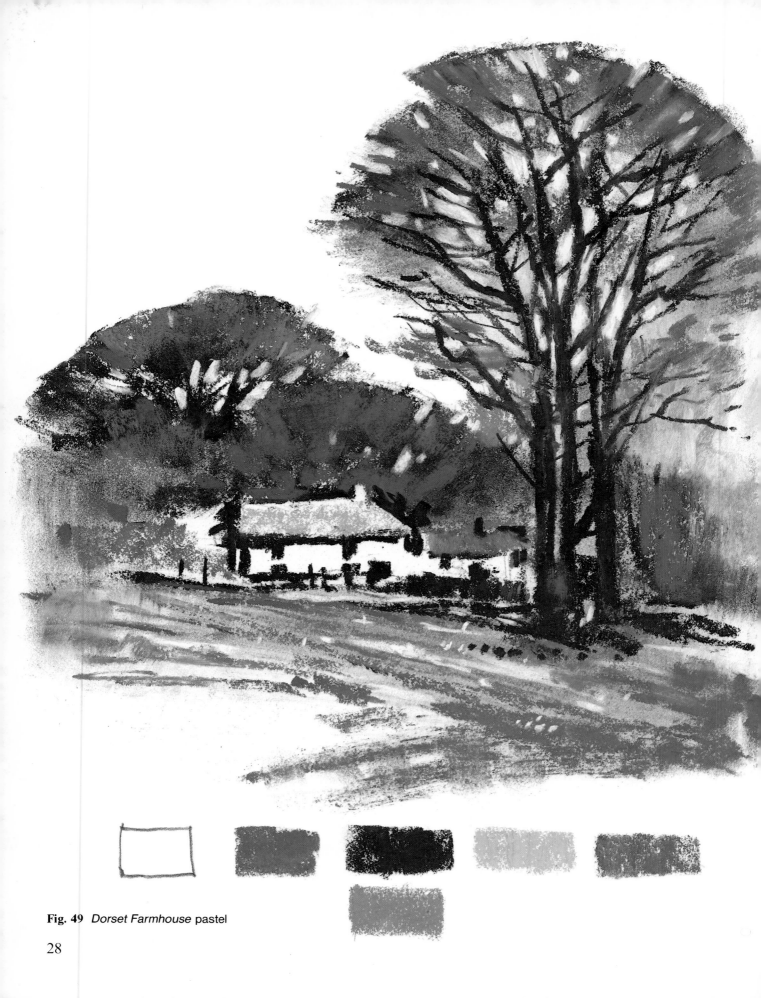

Fig. 49 *Dorset Farmhouse* pastel

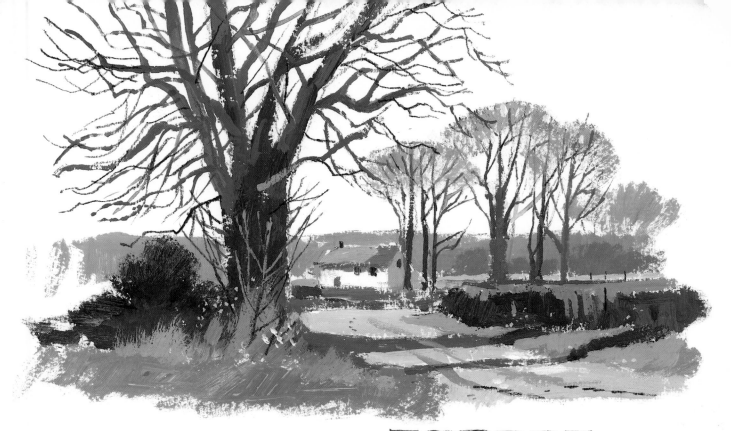

Fig. 50

are growing out of the ground, properly supported by a solid base of roots.

Although the vast range of pastels may be bewildering, you can start off with just a few quite effectively. For **fig. 49** I have used just five colours and white, which are shown underneath the sketch. First of all, I indicated the dark areas with black pastel, then fixed it with aerosol fixative – this prevents the undercolour black from smudging into the top colours. I applied the remaining colours directly onto the black pastel; you can see the effect on the trees behind the cottage. The cottage wall was left as white paper. When I had finished it I fixed it again with aerosol fixative; I now use CFC Free Low Odour fixative made by Daler-Rowney.

For my acrylic painting, **fig. 50**, I have again used five colours and white: Ultramarine, Crimson, Burnt Sienna and Cadmium Yellow. The painting is on Bockingford watercolour paper, which I use a lot.

Acrylics diluted to a watercolour consistency were used for my watercolour-style tree study shown in **fig. 51**. The colours I used are Ultramarine, Crimson, Yellow Ochre and Burnt Umber, and the paper is Bockingford. Because acrylics do not lift when dry I laid a very thin wash of Yellow Ochre over the whole sketch after I had finished it.

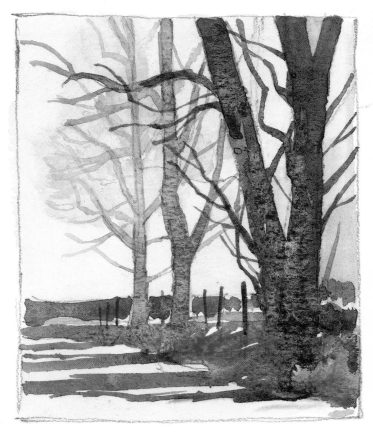

Fig. 51

29

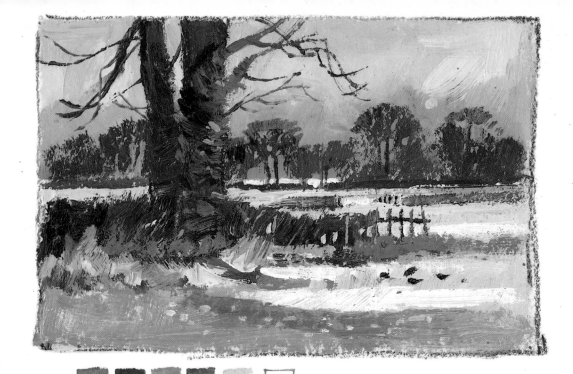

Fig. 52

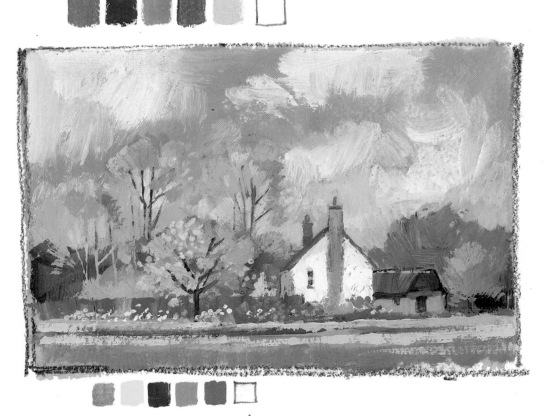

Fig. 53

Trees through the seasons

The colours of trees change with the seasons and this is the subject of my four-part demonstration. You may like to try a similar exercise to test your knowledge of colour mixing. You can use photographs for reference but try not to copy them exactly – remember, you are the artist, not the camera.

Winter (Fig. 52) I used acrylics on Bockingford paper. The colours were: Cadmium Red, Ultramarine, Yellow Ochre, Burnt Sienna, Cadmium Yellow and White.

Spring (Fig. 53) Oils on acrylic primed Bockingford paper, stained with Burnt Umber. The colours I used were: Yellow Ochre, Lemon Yellow, Cadmium Orange, Cadmium Red and White.

30

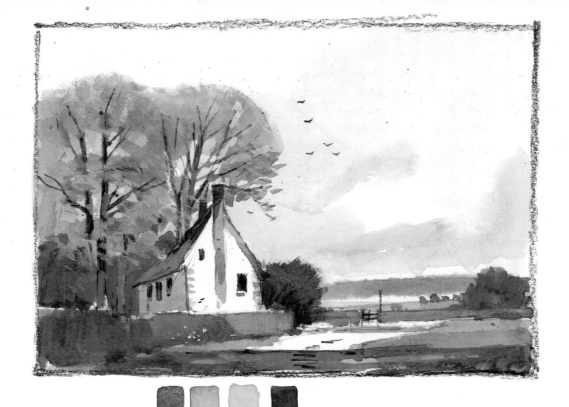

Fig. 54

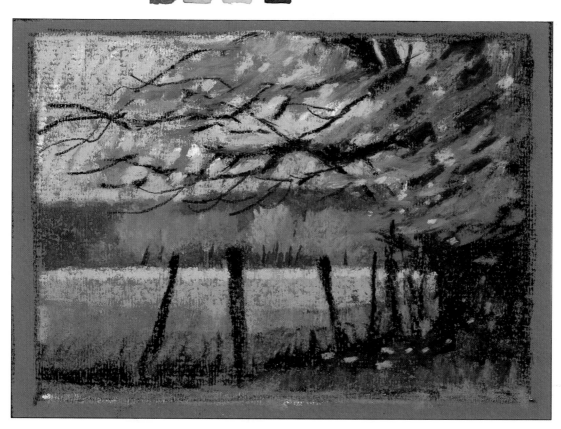

Fig. 55

Summer (Fig. 54) This simple watercolour sketch is also on Bockingford paper. I used four colours, Ultramarine, Crimson Alizarin, Lemon Yellow and Payne's Grey.

Autumn (Fig. 55) Pastel on brown pastel paper. The colours I used were: Reddish Purple No. 1, Lizard Green No. 5, Cool Grey No. 6, Sap Green No. 5, Yellow Ochre No. 6, Burnt Sienna No. 4, Cadmium Yellow No. 4.

PAINTING OUTDOORS

Painting outdoors can sometimes be very uncomfortable and frustrating; the light constantly changes and weather is often fickle, but for all the many problems involved the sheer pleasure of working direct from nature is ample compensation for any discomfort.

It is a mistake to think that you have to complete a painting outdoors to exhibition standards. A barrier is then immediately created because you have set yourself such a difficult target. The purpose of painting outdoors is really to capture an impression of the subject or to create a sketch painting for future reference.

Exercise One: oils

For your oil painting exercise I have included a photograph of the scene that I painted (**fig. 56**). It is not always practical or feasible to take photographs of each stage of a painting outdoors, so I have recreated in the studio the preliminary steps to the finished painting. The sequence and colours are exactly the same as those I used for my outdoor sketch.

Stage One (Fig. 57) You have already primed and stained a piece of Bockingford watercolour paper so we are ready to start. Set some basic colours out on your palette just to start off with – French Ultramarine, Cadmium Red, Cadmium Yellow, Crimson Alizarin, Burnt Sienna and Yellow Ochre. As your painting progresses I will suggest some more colours for you to add. Start off with your Daler-Rowney Bristlewhite long flat series B48 No. 6 and the smaller brush No. 3; a nylon brush, Rigger No. 3, will be used in the final stages. Using the larger brush, No. 6, for most of your painting will help make your work bold and expressive. Use as little white as possible so that your colours are pure. Mix Ultramarine and Cadmium Red and block in the position of the tree on the right and the tree on the left. A rough line to indicate the position of the stream is enough to give you a guideline for the composition. For the early stages, mix gel medium with the paint to hasten drying. Later on when you paint the trees the preliminary painting will be dry enough for you to paint over the top.

Stage Two (Fig. 58) Although the distant hills are not visible I would like you to leave space between the far trees to create the effect of recession, so with Ultramarine and a touch of Cadmium Red roughly indicate the hills as I have shown you. The mood of the sky deter-

Fig. 56

Fig. 57 Stage One

Fig. 58 Stage Two

Fig. 59 Stage Three Fig. 60 Final Stage (below)

moment and indicate the areas of grass and foliage, with Ultramarine, Cadmium Yellow and Burnt Sienna. Don't worry too much about accuracy at this stage – I want you to develop a free style.

Stage Three (Fig. 59) You can now define the tree shapes and indicate recession. To do this mix Ultramarine, Burnt Sienna and White for the furthest tree on the left – the emphasis of blue gives it a sense of distance. The leaves are just beginning to change to autumnal colours, particularly the tree on the right. To get this golden colour mix Cadmium Orange, Crimson and Cadmium Yellow, and for the darker parts add some Burnt Sienna. The mauve colour with which you initially painted the large tree can be retained for the shadowy parts, but when you add more to the sky you can cut in the final shape. These colours will be used when giving the final touches to your painting, so remember how you mixed them.

The painting is still in a rough and broad style. Now you can start pulling it together.

Final Stage (Fig. 60) With the autumnal colours you have already mixed, indicate the general shape of foli-

mines the quality of light and its effect on the landscape. The sky needs to be interesting and, bearing in mind the sunlight and shadow you will be including later on, mix Ultramarine, a touch of Burnt Sienna with a similar amount of Cadmium Red and lots of White; then mix gel medium with the colour and paint in the sky freely with bold brush marks. Leave the sky for the

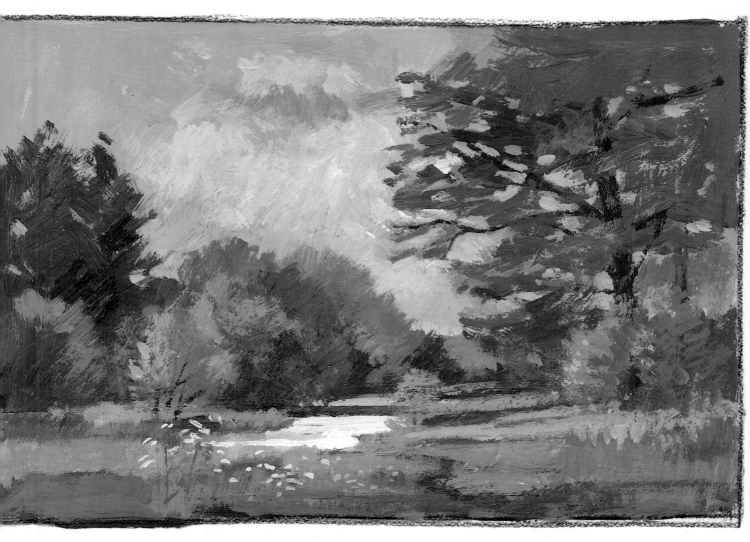

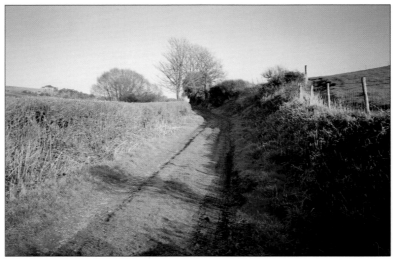

Fig. 61

Fig. 62 Stage One

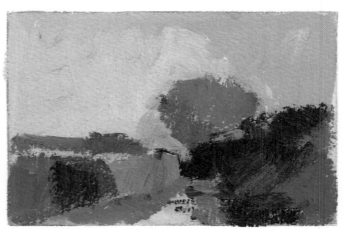

Fig. 63 Stage Two

age of the right hand tree, following the outward movement of the branches. The distant hills are too blue and need to be greyer. Mix Ultramarine, Burnt Sienna and White and paint over the blue, making sure the edge is not too clearly defined. Now comes the most exciting part of your painting – adding a few touches of contrast to give it punch! Cadmium Green, Ultramarine and Cadmium Yellow with White are the colours to mix for the bright sunny parts of the grass. The foliage on the right hand tree is too compact, we want the birds to fly through! Mix a sky colour, slightly darker than the main area of sky and paint round the branch shapes. Also with the same colour, create spaces in the foliage. Indicate some branches with your rigger brush. The final touches are a flash of sunlight on the water, painted with White and Yellow Ochre, and the same colours for the foreground flowers. When your painting is touch dry you can varnish it with retouching varnish. It can be mounted to the smooth side of hardboard, or on stout Conservation Board.

Exercise Two: acrylics

For your next exercise we can go down the lane outside my studio. The lane is quiet, so you will not be bothered by onlookers. We will be painting on Bockingford paper as we did in the previous exercise. I have included a photograph of our subject (**fig. 61**) so you can see how the view will be modified to make a stronger composition. I think there is too much emphasis on the lane – the main point of interest is really the group of trees at the end. Using your viewfinder, isolate the foreground until you can see only the group of trees. The basic palette is: Ultramarine, Cadmium Red, Cadmium Orange, Cadmium Yellow, Lemon Yellow, Burnt Sienna and Monestial Blue.

Stage One (**Fig. 62**) Mix Ultramarine and a touch of Cadmium Red (no White), and block in the hedge in shadow, and also the position of the trees.

34

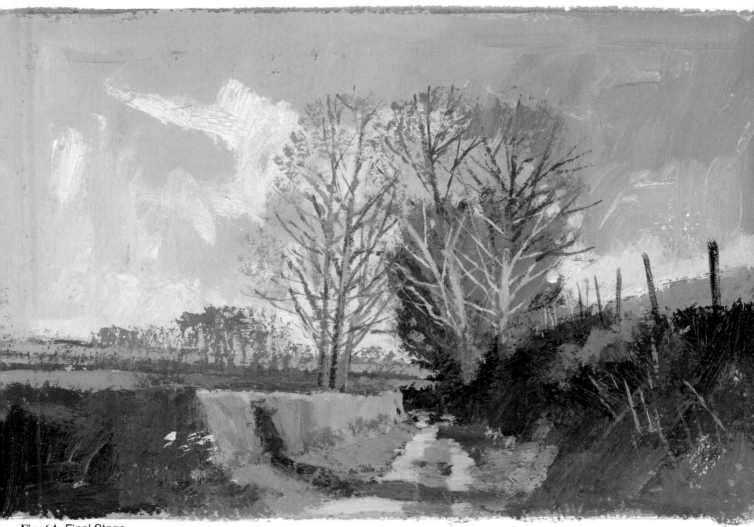

Fig. 64 Final Stage

Stage Two (**Fig. 63**) The green of the verge and ever-green tree is mixed from Cadmium Orange, Cadmium Yellow and Ultramarine. Be careful not to use too much white otherwise your colours will be chalky. For the shadows nearest to you add more blue and red, particularly on the right hand side where the shadow is deepest. You can already see the effective contrast of light and dark. Now paint in the sky, mixing Ultramarine, White and a touch of Cadmium Red. Because acrylics dry quickly you will be able to paint the trees after a very short time. Add Lemon Yellow to your palette and mix Burnt Sienna and White for the hedge on the left. Mix Lemon Yellow with Monestial Blue for the sunny grass (be careful with the blue, it is a very powerful colour). For the path mix Lemon Yellow, White and Burnt Sienna.

Stage Three (**Fig. 64**) With Burnt Sienna, Cadmium Yellow and White, mix a light colour for the trees on the right, and then, using your nylon rigger brush, paint in the trunk and branches, making them darker against the sky. Add a little more Burnt Sienna for the tree on the left. Cadmium Yellow, Ultramarine and a touch of Cadmium Red are the colours to mix for the foliage, which you paint with a partially dry brush. The distant trees are purple, mixed from Crimson and Ultramarine. Use your No. 3 brush and carefully dry brush in the trees. Your painting is now nearly finished, except for part of the sky. Mix the cloud colour from Ultramarine with a touch of Yellow Ochre and White, then with your No. 3 brush and the rigger put in the patches of sky which show through the branches. Add the posts and cow parsley to the foreground and your painting is complete. When you get home keep your painting in a warm atmosphere. Next day it will be dry enough for you to varnish.

All the time you are outdoors painting, you are learning something new, whether it be about the colours of autumn or the shape of a tree against a summer sky.

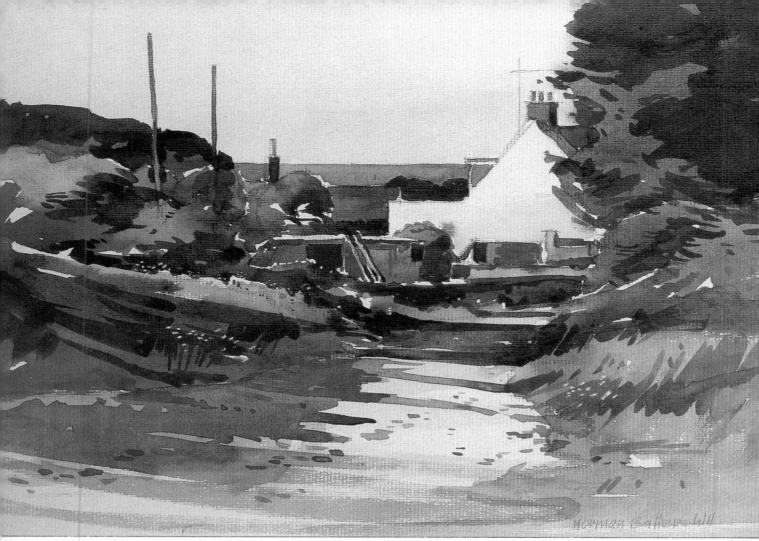

Fig. 65 *Portland, Dorset* watercolour

Watercolour studies

Figure 65 is a painting in watercolour on grey pastel paper. The fascinating Isle of Portland, Dorset, is a place where I have done a lot of outdoor painting. The quarries and stone cottages provide endless subjects for the landscape artist, but there are very few trees on this wind-swept and unique island. I painted my watercolour at 7.30 a.m., on a morning when the early sun cast interesting long shadows. The building at the end of the track is the hotel where I stayed, and beyond it is the sea. Behind me the track led to a vast quarry. All around are fascinating views. I chose this subject because the end wall of the hotel made a strong pattern and the shadows across the track harmonized with the distant horizon of the sea. The grey pastel paper made a delightful tone to work on. I have not used any white paint at all. The painting is direct and free in style, which seemed to match the mood of the subject.

I used very few colours, the emphasis being on green; my palette consisted of Ultramarine, Prussian Blue, Cadmium Yellow and Burnt Sienna. I mixed Prussian Blue and very little Cadmium Yellow to emphasize the blue content of the darker shadows. Foliage in summer is not easy to represent, but I was careful not to fall into the trap of showing individual leaves, which would have spoilt the impression I wanted to convey. My painting is an interesting composition; the main point of interest is the building and sea beyond, the trees on either side are unequal in balance but frame the chief focus of attention. For the sky I kept to the colour of the paper and only added a blush of Ultramarine to the horizon to give a sense of distance. The two poles create a contrast of verticals with the horizon, as does the television aerial. Painting in the early morning sun was a very pleasurable experience. My watercolour was started and finished outdoors with nothing extra added afterwards, and I was quite pleased the painting went well. I finished it in about two hours and returned to the hotel to have a well-deserved appetizing breakfast.

Trees in a busy street is the theme for my outdoor sketch in watercolour (**fig. 66**), painted from the car. It is broadly treated with no attention given to detail. Sketches like this are not intended to be regarded as finished paintings, but are done for practice and pleasure. The colours I used are Payne's Grey, Burnt Sienna,

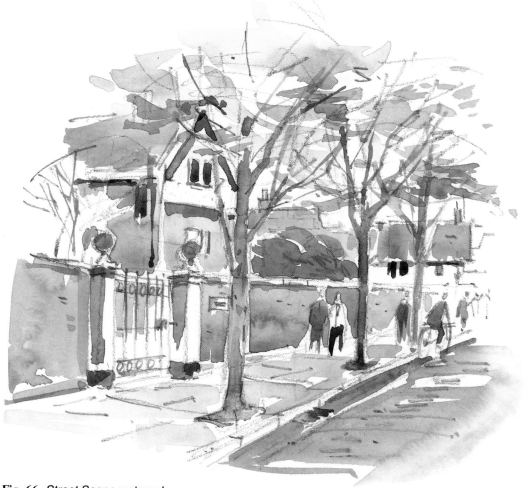

Fig. 66 *Street Scene* watercolour

and Crimson Alizarin. I allowed myself a touch of Cobalt Blue for the cyclist's jacket.

My watercolour (**fig. 67**) was started in the car and completed in my studio. The problem here is that the painting may be overworked in the studio and lose its spontaneity. Knowing when to stop is essential; as soon as you start fiddling, put your brush down and resolve not to do any more. My own method used to be the simple expedient of signing the painting when I considered it half-finished – it works!

Carrying oil colours or acrylics in a box for any distance can become tiring. You may like to know how I have reduced the weight of my painting kit. Instead of painting on hardboard as I usually do with oils or acrylics, I prime several pieces of Bockingford watercolour paper with Daler-Rowney acrylic primer, and when dry I stain it with diluted acrylic Burnt Umber. The stain serves two purposes; it reduces the glare of white paper and is a nice warm tone to paint on. Six pieces of paper about 10×7 in (254×178 mm) clipped to a piece of board are a fraction of the weight of the equivalent number of pieces of hardboard.

After you have found a suitable subject view it from several angles and remember to choose something simple to begin with – don't be tempted to paint the interior of a forest. If you are not sure about the view try out some small exploratory pencil sketches first. Starting a painting confidently contributes a lot to its success, so be sure of what you want to do.

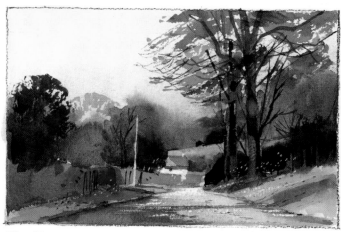

Fig. 67

PAINTING IN THE STUDIO FROM SKETCHES

Creating a landscape painting in the studio from your outdoor sketches is immensely satisfying, and a sure way of making progress. Working this way demands a great deal of imagination, and calls upon your powers of visual retention. As you gain experience even the simplest sketch can be used for a studio painting, which is why I ask you to keep all your outdoor sketches. I shall take some pages from my sketchbook and show you how I incorporate part or all of them in a finished painting. This is something I have learned over a long period of time, so don't be discouraged if you find it difficult at first – keep persevering.

The two pages from my sketchbook (**figs. 68 and 69**) gave me the idea of putting them into a landscape pastel painting (**fig. 70**). I used two Daler-Rowney

Fig. 68

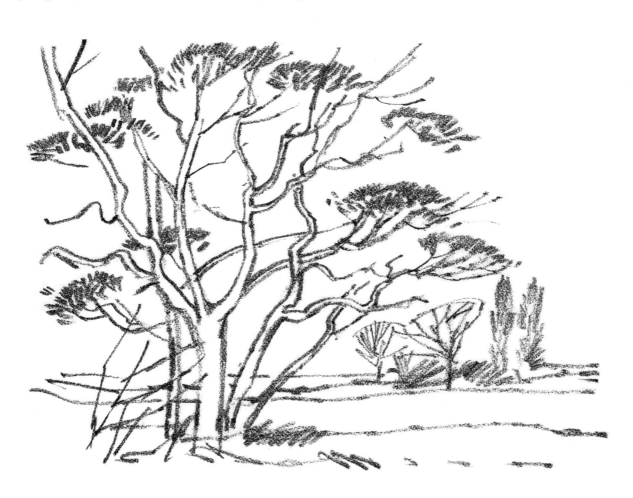

Fig. 69

38

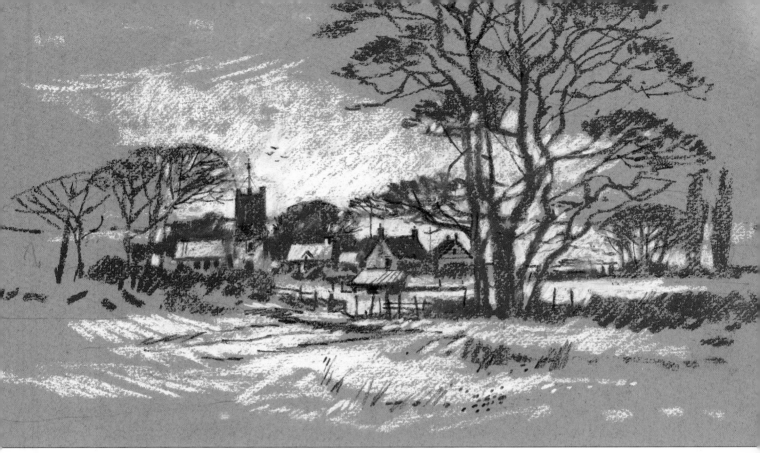

Fig. 70 *Dorset Village* pastel

pastels, White No. 16 and Cool Grey No. 6, on a neutral green-grey pastel paper. My 4B pencil sketch of trees will fit in quite well with the sketch of the church tower and buildings. To allow for possible alteration, I very lightly sketched in the composition with the Cool Grey pastel. (I seldom draw in a pastel painting with a lead pencil because it can leave a shiny mark.) The position of the main group of trees is important, acting as a balance to the silhouetted church tower and farm buildings. I like the style to be quite broad, which suits the character of this lovely medium. After drawing in the composition I used the White pastel to indicate the sky and the effect of light on the buildings and fields. To prevent smudging I then fixed the painting with aerosol fixative, and sketched over the top, adding finishing touches which completed this very simple painting.

I suggest that you copy this picture with the same colour pastels. You will learn a lot about the contrasts of light and dark from this exercise, which is an important means of giving life to your painting. Even a slight drawing can be made interesting by the contrast of light and shade, as my sketches (**figs. 71/72**) illustrate. Both are the same subject. Try a similar exercise, using some of your own sketches and creating the effect of contrasting light and dark. They do not have to be detailed or complicated, and can be in pencil, charcoal, or pastel on cartridge paper. Many of my demonstration paintings have been worked out this way beforehand.

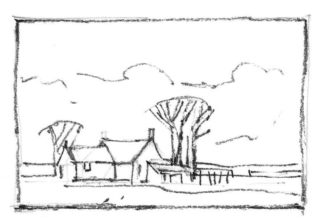

Fig. 71 *Farmhouse* pencil

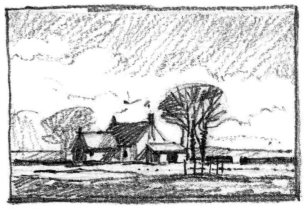

Fig. 72

39

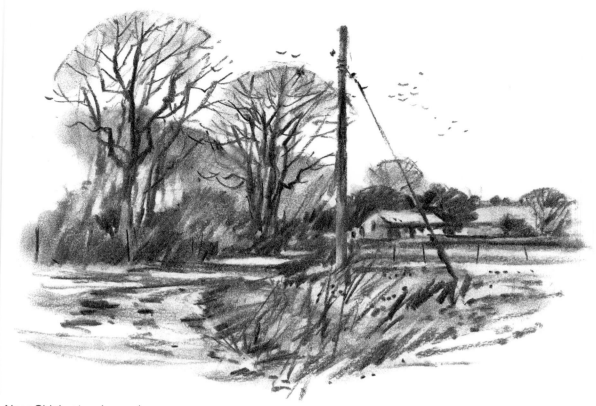

Fig. 73 *Near Chichester* charcoal

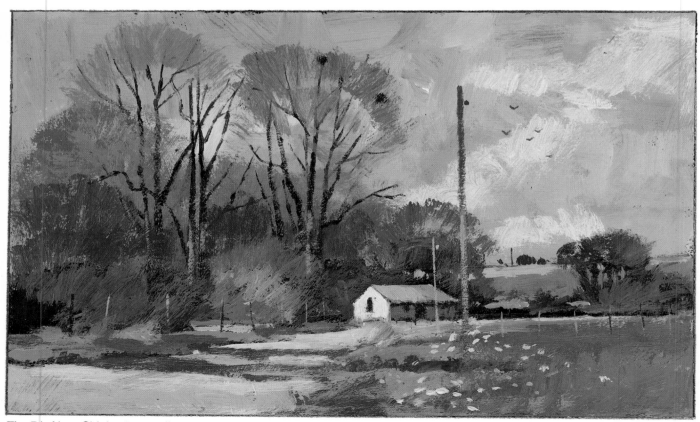

Fig. 74 *Near Chichester* acrylic

40

My charcoal sketch (**fig. 73**) was done outdoors in a quiet lane near Chichester in Sussex and I made an acrylic studio painting from it (**fig. 74**). I did not have to create contrasts of light and dark, as fortunately the day was sunny, and I took advantage of the natural contrasts in my sketch. I lightly sketched in the composition with a 2B pencil on acrylic primed Bockingford watercolour paper.

The sky was painted first with a mixture of Payne's Grey, Crimson and Yellow Ochre. The field and grass bank were painted with a mixture of Ultramarine, Cadmium Yellow and Burnt Sienna. For the roadway I used Payne's Grey and a touch of Burnt Sienna to warm the colour. Next I put in the background trees, mixing Ultramarine and Crimson, softening off the edges with a dry brush. When this had dried I added the darker trees and made the colours quite strong, mixing Payne's Grey, Burnt Sienna and Yellow Ochre, and carefully dry brushing the edges to suggest twigs. Finally, I added the shadows and the pole in the foreground and completed the picture (**fig. 74**). I was quite pleased with the result.

Changing the medium

Sometimes you may want to work in a different medium from that which was used for an outdoor col-

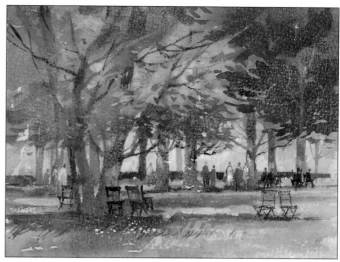

Fig. 75

our sketch. I have developed my watercolour sketch of the park (**fig. 75**) into a pastel painting (**fig. 76**) and also extended the width to make a wider vista. I have not used any additional reference – a very good test of imagination and memory! My pastel painting is on blue pastel paper and you can see how the background colour and change of format creates a totally different concept of the subject.

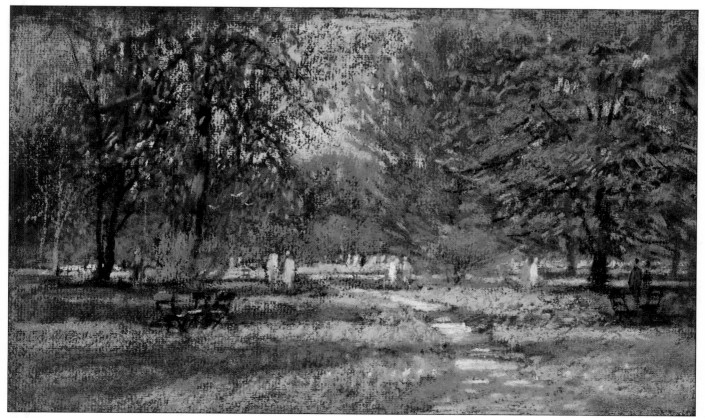

Fig. 76

My acrylic painting of trees in the snow was painted in the warmth of the studio, using an outdoor pencil sketch done some time previously.

Stage One I first sketched in the general layout (**fig. 77**) on Bockingford watercolour paper primed with acrylic gesso. This paper has a nice texture, ideal for acrylic painting. The stain was diluted acrylic Burnt Umber. I used a No. 5 Daler-Rowney Bristlewhite long flat brush and a Rigger No. 3.

Stage Two I always establish the darks first in an acrylic or oil painting (**fig. 78**). For the trees in the middle distance I mixed Ultramarine, Cadmium Yellow and Venetian Red. The foreground trees are darker and richer in colour so I used the stronger Indanthrene Blue, Yellow Ochre, Venetian Red and Cadmium Yellow. To achieve a sense of broadness in my painting, I kept the foliage free of any small detail.

Stage Three Snow is never pure white, it reflects lots of warm colours. When I painted the snow (**fig. 79**) I added several colours to Titanium White – Crimson, Yellow Ochre, Venetian Red, Cadmium Yellow and Cobalt Blue and Ultramarine. The sky was painted last – it is exciting cutting round the edge of trees and creating spaces in the foliage. The colours I used were White, Cobalt Blue, Ultramarine and Crimson. A couple of telegraph poles in the distance complete my snow scene in acrylics (**fig. 80**).

You can have a lot of fun by developing a theme from your outdoor sketches. Your 'theme' may be an aspect of weather, or a season, a number of sketches combined in one subject, or perhaps a painting created from an imaginative sketch. But to start with keep the subject simple and avoid too much detail. Gradually you will find your confidence and skill increasing until you reach the stage where you can visualize a painting from a pencil sketch.

My acrylic painting (**fig. 81**) is on canvas, mounted to hardboard. I used only a few colours, Monestial Blue, Cadmium Red, Yellow Ochre, Cadmium Yellow Pale, Burnt Sienna and White. It is a simple composition using basic principles – the strong verticals of the two trees are counterbalanced by the horizontals of the river bank, fields and distant trees; without this the main tree would look too prominent and unbalanced.

I used a lot of Burnt Sienna and Cadmium Red to modify the greens, but also tried to keep a richness and depth of colour. The distant trees are Monestial Blue with just a touch of Cadmium Red. I painted the picture in the studio from notes taken on the spot. The main tree was actually very complicated, with a mass of branches and overhanging leaves, but I was more interested in its silhouette, and the few patches of sky showing through the foliage. There were also a lot of reeds on

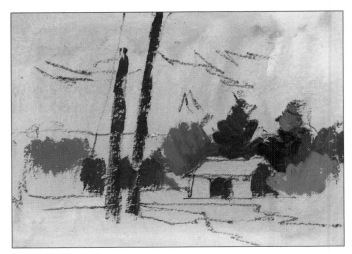
Fig. 77 Stage One

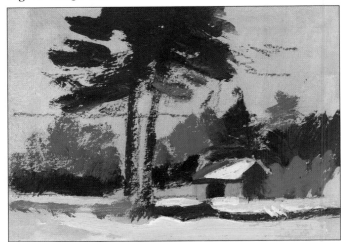
Fig. 78 Stage Two

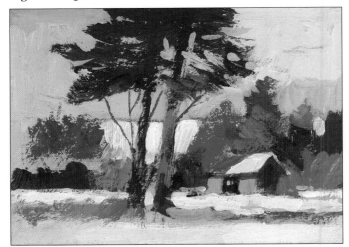
Fig. 79 Stage Three

the opposite bank but I decided to delete them because I thought they would make the painting too fussy. I used a Daler-Rowney Bristlewhite series B48 No. 5 brush for most of the picture and also a No. 2 brush.

42

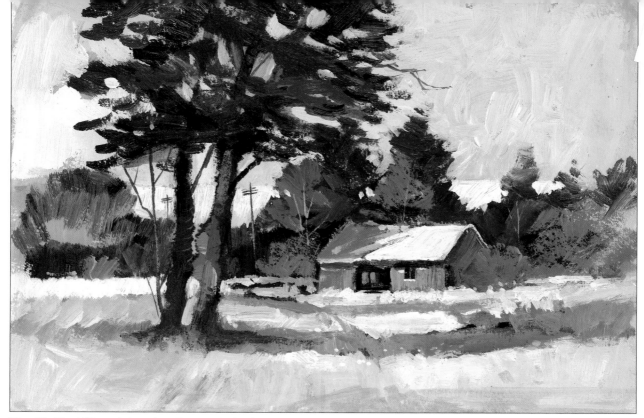

Fig. 80 Final Stage (above) **Fig. 81** (below)

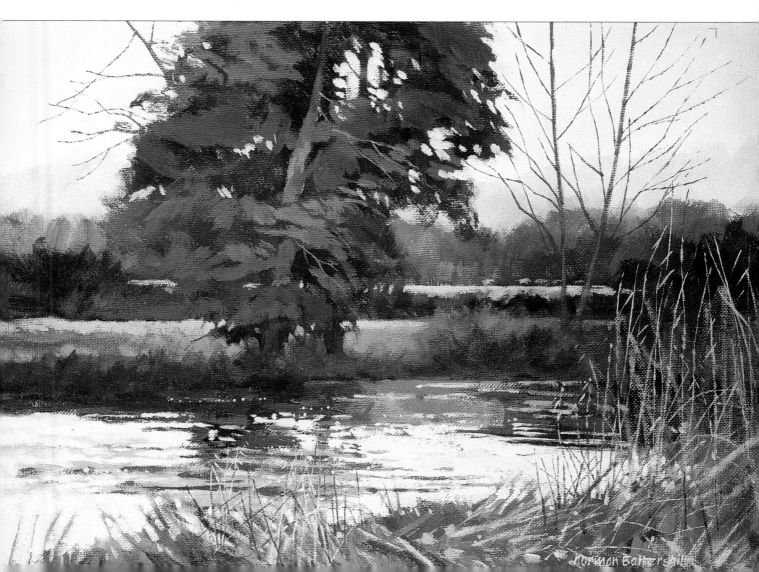

CREATING ATMOSPHERE

Painting a particular aspect of weather creates a sense of atmosphere and can give added interest to the subject. The sky is essential in establishing both the quality of light shed on the landscape and the mood of the painting. Trees can also contribute a great deal to the atmosphere of a landscape painting.

I like sketching skies outdoors with a broad medium such as charcoal, or pastel. Almost all of my studies are quite small, and done on pastel or cartridge paper. When you begin your studies, start in the middle of the paper – clouds often move swiftly, so you need space to sketch them. Make a note of wind direction and the position of the sun. You don't need to depict extremes of dramatic weather – a summer sky with wisps of cloud also has atmosphere. Try out different drawing mediums for your studies. You may find one that suits you better than another.

Atmospheric sketches

Small atmospheric sketches are fun to do; I have included three sky studies in different mediums so that you can see the contrasting effects in each one. In **fig. 82** I have used just two Daler-Rowney pastels, Cool Grey No. 6 and Silver White (Blue Shade) on medium grey pastel paper. I have not tried to make a finished sketch because I want you to note the broad effects and contrasts created in a simple monochrome sketch. Charcoal is equally expressive, and for **fig. 83** I used a thin stick on cartridge paper. To get areas of tone I gently smudged the charcoal with a small piece of kitchen tissue. For the clouds and the streak of sunlight I lifted out the charcoal with a putty rubber. A soft pencil is not so effective in creating large areas of tone as charcoal or pastel, as you will see in **fig. 84**.

Painting skies

After you have completed a number of sketches you can move on to painting skies outdoors. Again, these studies can be quite small, say, 7×5 in (178×127 mm); the important thing to remember is that you are trying to capture impressions of the sky, not an exact likeness. Because you may have to work fast your sketch is likely to be vigorous in style.

If you want to emphasize an expanse of sky in your painting the horizon should be low; see **fig. 85**. To emphasize the foreground you make the horizon high, as I have done in **fig. 86**. For **fig. 87**, my acrylic painting,

Figs. 82, 83, 84

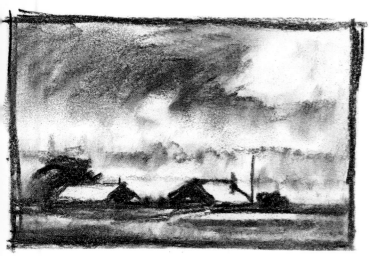

Fig. 85

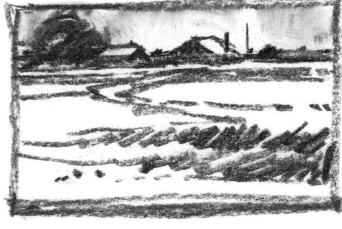

Fig. 86

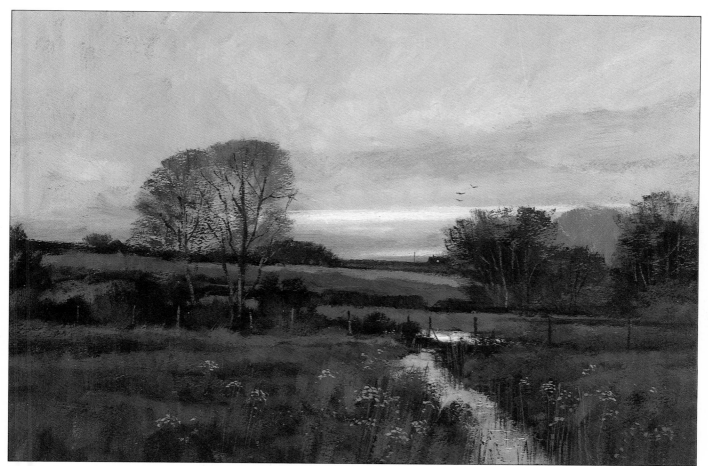

Fig. 87 *Dusk* acrylic

the horizon line is a little below the centre, but because the landscape is much darker in tone than the expanse of sky, the feeling of atmosphere is emphasized. Notice how I have slightly angled the streak of light in the sky – if I had made it horizontal it would not have appeared so interesting. When you paint a picture with a lot of sky remember the importance of trees in giving scale and a sense of recession. The trees in my painting break the skyline in several places and give recession to the landscape. The subject was imaginary, painted in my studio, and I was pleased with the twilight effect I managed to achieve.

Before you begin your picture you must have a clear idea of the atmosphere you want to create, as changing your mind half-way through could be a disaster. Once you have an idea it is a good plan to rough it out in the form of a small sketch, using pencil, pastel or charcoal. You may, for instance, decide on the theme of dusk or dawn. You can create variations on a theme, as my charcoal sketches (**figs. 88 to 91**) illustrate. If you wish, paint from these illustrations or use them as a basis for developing your own ideas. An outdoor sketch can be developed to make it into a picture (**fig. 92**); my sketch has been left half finished to show you how I painted over a pencil drawing done outdoors.

Paintings of sunsets have a tendency to look a bit clichéd. Nature has a way of producing vivid colours that somehow harmonize; the artist, however, has problems in producing similar subtle harmonies with a box of paints. To overcome this problem, you can try staining the support beforehand with a thin wash of Burnt Umber or Yellow Ochre acrylic, which will help to unite the colours. The watercolourist can apply a very thin wash of Raw Sienna.

My rough pastel sketch (**fig. 93**) has the possibility for a larger studio painting and is based on a scene not far from my studio. It was a crisp winter day and I liked the simple composition. The pastels I used are: Intense Black, Silver White, Coeruleum, Lizard Green, Vandyke Brown, Ultramarine, Madder Brown, Purple Brown and Cool Grey.

Whenever you are out try and get into the habit of making a mental note of the weather – can you remember what the sky looked like yesterday? Because I live in the country I am very much aware of the ever-changing effects of light and nature's various moods. But even when I worked in London many years ago, I used to arrive at my office an hour before anyone else to make studies of the sky through the window.

I have spent most of my painting life trying to capture the elusive qualities of a landscape's atmosphere, and I imagine this pursuit will never end. You don't have to lash yourself to the mast of a ship to gain first-hand experience of a storm, as Turner did, but every time you are outdoors be aware of the foliage of trees moving in the wind, frost and rain, the sun behind falling rain, the wind in the pines, reflections in a puddle, an evening sky, early morning light – there are so many things for you to experience and enjoy. Later on in the studio you will be able to express some of these experiences in your painting.

At the risk of being repetitive, I will again mention those great landscape painters, Constable and Turner, who were masters at creating a feeling of weather and atmosphere in the smallest of sketches and paintings. You cannot do better than look to these artists for inspiration, remembering that their masterpieces were created within the confines of a studio.

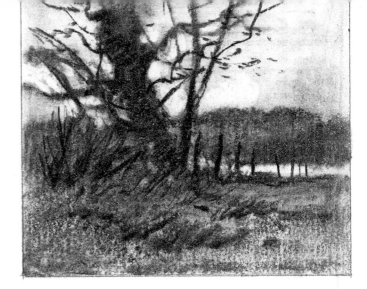

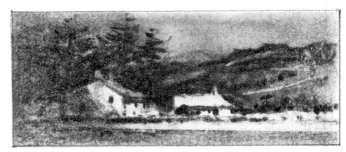

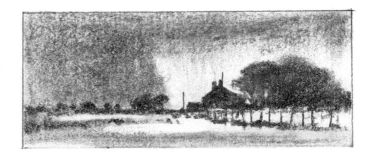

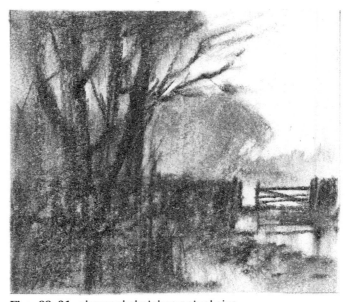

Figs. 88–91 charcoal sketches actual size

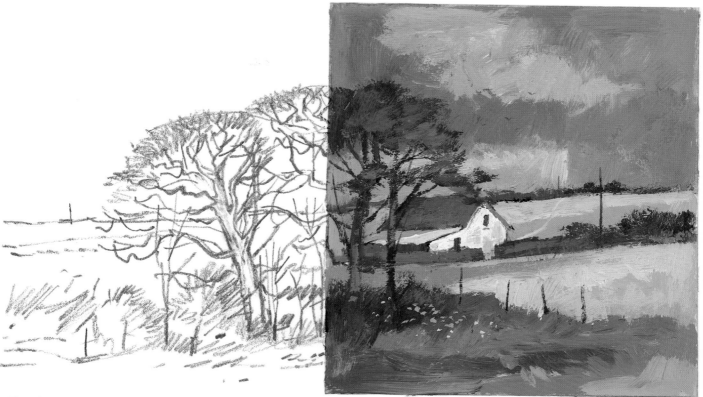

Fig. 92

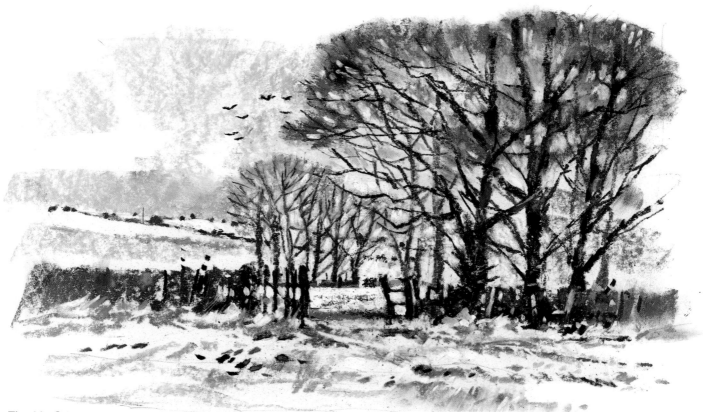

Fig. 93 *Crisp Winter* pastel

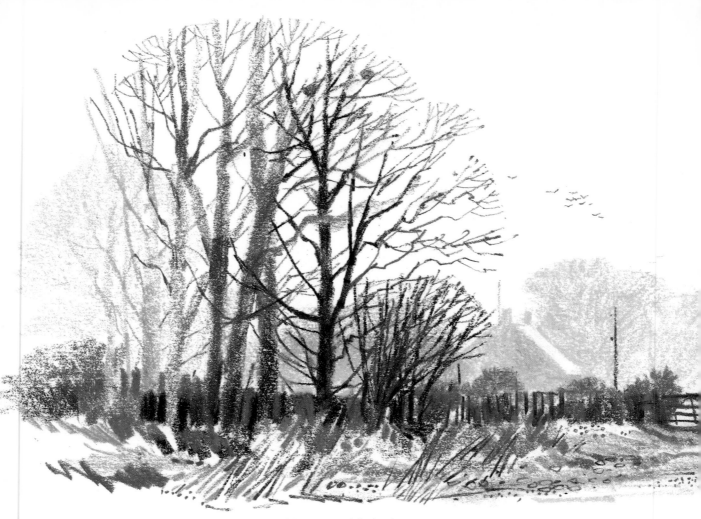

Fig. 94 *Early Morning Light* crayon　**Fig. 95** *Dorset Village* pastel (below)

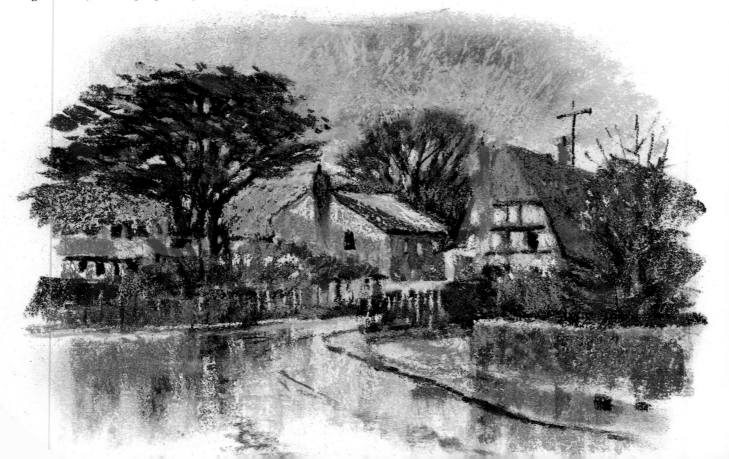

My crayon sketch (**fig. 94**) is an example of trees in a simple composition. By silhouetting the distant trees and house with soft grey and not including any sky, the atmosphere of early morning softness is suggested. Notice how the trees and foreground are strong in colour to emphasize the background effect. I was careful to make the trees on the left different in tone; the temptation was to make them all very dark to achieve the maximum contrast, but varying the tones adds to the sense of their receding into the background. The rook's nest at the top of the trees gives an important indication of height and scale. An atmospheric effect can be as subtle as that shown in this picture or bold but whatever effect you choose, the concept and treatment should be positive if you wish to achieve a convincing naturalness.

I developed this pastel sketch (**fig. 95**) from notes and a drawing done outdoors. The Dorset village shown is not far from where I live. A wet day with trees dark against the sky creates an interesting atmosphere, and you may like to try this as a subject. My pastel is on white cartridge paper. First of all I lightly sketched in the composition with charcoal and then I indicated all the large areas of dark colours, working from dark to light. I fixed the sketch with Daler-Rowney fixative.

A sense of atmosphere need not be confined to open landscape subjects but may also be conveyed in restricted spaces such as the woodland interior shown in **fig. 96**. The wood was dense but to simplify it I deleted all but the essential trees. The colours I used for this watercolour, done on cartridge paper, were Payne's Grey, Yellow Ochre, Ultramarine, and Crimson Alizarin. After the watercolour was completely dry I carefully sponged out the background to give a misty, soft-edged effect. If you do this to a watercolour you must take care not to destroy the surface of the paper. A soft misty effect can also be achieved by applying watercolour to wet paper but considerable skill is necessary to control the paint and create the desired effect.

Fig. 96 *Woodland* watercolour (below)

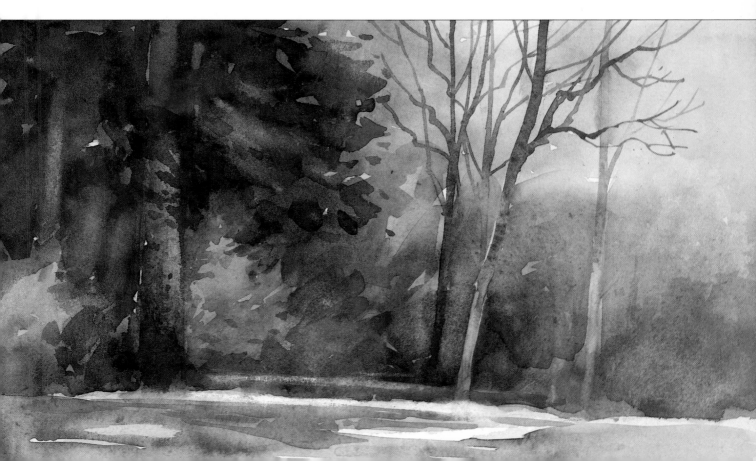

PAINTING FROM PHOTOGRAPHS

Some artists frown upon the use of photographs, but as a source of reference and a reminder of colour and atmosphere a photograph can be very useful. It is always best to use your own photographs because it is *you* who have been there, selected the subject and viewpoint, and had experience of the place. Sometimes it is impractical to sketch or paint from a particular vantage point, especially in a road or busy thoroughfare, but the camera can conveniently record the subject for you. When you work from a photograph try not to be intent on copying it, but use it as a starting point for your painting. When you have got your picture under way, put the photograph away and resist the temptation to look at it. How you make use of your photograph is a personal matter, but always remember you are an artist not a copyist.

Photographs of trees are often misleading, for even a mass of summer foliage can appear flat, lost in shadow or look 'cut-out'. But if you have acquired a knowledge of trees by sketching and painting outdoors this lack of

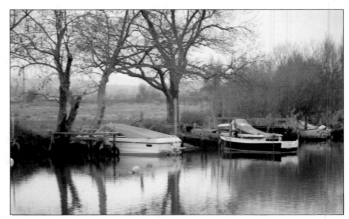

Fig. 97

information will not worry you. An excellent method of learning about tone values and the use of colour is to paint a full colour picture from a black and white photograph. This is an exciting challenge.

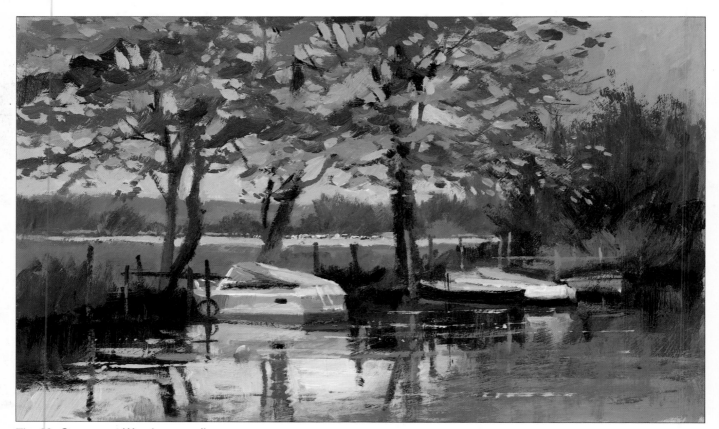

Fig. 98 *Summer at Wareham* acrylic

Shifting the focal point

When you paint from photographs it is sometimes necessary to shift a focal point. For example, in the photograph opposite (**fig. 97**) all the interest is along the line of trees and moored boats – therefore that is the focal point of the subject. The eye is led out of the picture on the right. The subject is basically divided into two separate areas of foreground and distance; I would prefer to create a middle distance so that the subject has added interest and depth. Of course you may prefer to keep a photograph as it is without altering anything. But you can see from my acrylic painting (**fig. 98**) the difference I have created just by introducing an effect of sunlight across the distant fields, which shifts the focus into the background. The sunlight also repeats the horizontal line of the trees and boats, making a more balanced composition. Although it was a dull winter day when I took this photograph at Wareham, I have changed the painting to a sunny summer day, adding foliage to the trees and bushes. My studio painting is on Bockingford watercolour paper, primed with acrylic primer and stained with acrylic Burnt Umber. The colours I have

Fig. 99 Fig. 100 *Winter Landscape* watercolour (below)

used are Cobalt Blue, Crimson, Lemon Yellow, Ultramarine, Cadmium Red, Cadmium Orange, Bright Green, and White.

My next painting is based on the photograph of a farm track near my studio (**fig. 99**). I added trees and also created the effect of sunlight to give the picture interest. My painting is in watercolour (**fig. 100**) and the

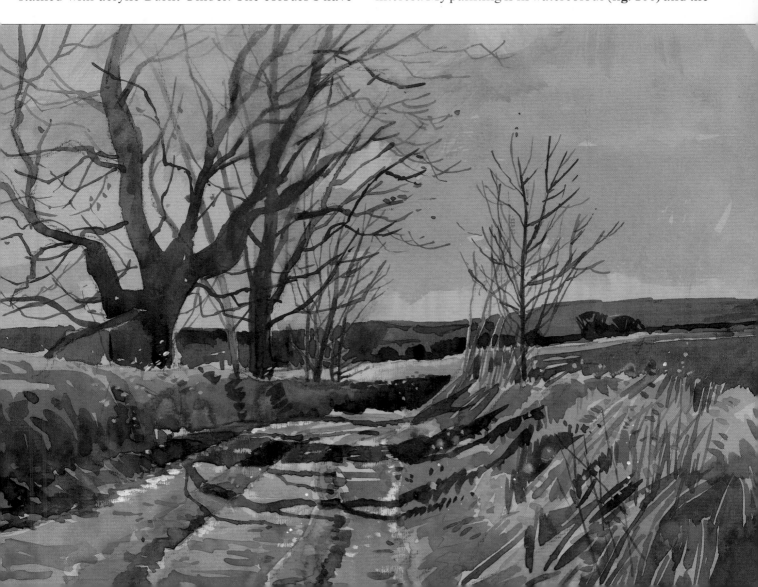

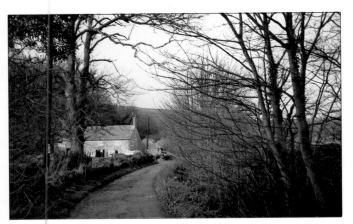

Fig. 101

the blue paper to suggest branches and twigs. This method of creating shapes out of a dark background is time-consuming and a bit tedious, but the effect is worthwhile; I also use this technique when painting in acrylics and oils. My friend Brian lives in the cottage, and his washing on the line adds a nice touch to this rural subject, completing my pastel painting.

I have included this photograph and pastel (**figs. 103** and **104**) to show you how a photograph can be drastically simplified but still retain the essence of the subject for a painting. Here the number of trees has been reduced and the gulley made into a bridge.

You will only make photographs work for you in creating successful studio paintings if you have the experience of painting and drawing outdoors. There is no other way of achieving a sense of naturalness in a painting. A photograph of a tree may give you a lot of information, but it cannot be a substitute for the living thing in its natural environment. Many artists, however, use photographs for their convenience and because they can provide a springboard for ideas – it all depends on your style and how you want to paint. I admire the technique and skills of the super-realist artist whose work closely resembles a photographic image. This is not my style, though, and when using a photograph I prefer to translate the subject into what suits my own approach and technique. I can truthfully

colours I used were Payne's Grey, Crimson Alizarin, Ultramarine, Cadmium Yellow and Yellow Ochre.

For the painting here I used the photo (**fig. 101**) almost as it is, but made it a sunny day. My painting (**fig. 102**) is in pastel on blue pastel paper. First of all I lightly sketched in the subject with charcoal and gradually built up the colour areas. Although I have kept fairly close to the original the result is a painting, not a copy of the photograph. The trees on the right were lightly sketched in with black, then I carefully cut round each line with sky colour. I have left some of

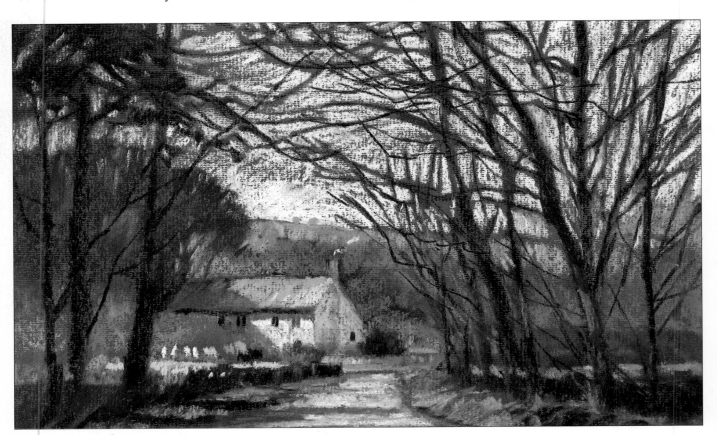

Fig. 102 *Brian's Cottage* pastel

say that photographs of trees have not greatly increased the knowledge I have gained by painting and drawing them outdoors.

Sometimes a photograph contains enough information for me to use it as a reference for the shape of a tree, particularly if I have taken it in winter when the structure is evident. But invariably it is necessary to make some alteration to suit the design or theme of my painting.

A great deal, of course, depends on how interested you are in photography – you may want to take a lot of care getting photographs of a high standard, or be content with snaps from a no-fuss fully automatic camera which slips conveniently into your pocket. Whatever the case, though, it is inadvisable to rely too much on a photograph, particularly if you want to record a group of trees in foliage, for you may not be able to distinguish which are in front of the others. If you find that you are becoming too dependent on the camera for picture making, leave your camera at home next time you go out painting, and just make sketches instead. You will learn more about your subject that way. Be careful – sometimes a photograph or slide can give a false impression of colours, and a particular film may have a tendency towards a green or a blue cast; look out for that, and make your own colour notes.

It is worth looking at the work of artists who are

Fig. 103

known to have made good use of photographs. Degas cropped photographs and in that way produced interesting compositions for his paintings. Sickert often painted from newspaper photographs, and David Hockney also has a collection of photographs for reference purposes. But none of these artists, you will notice, lacks the ability to draw, and all create paintings of great individuality. So be selective when working from photographs, and realize that you will invariably have to alter or modify part of a photograph to create a satisfactory composition.

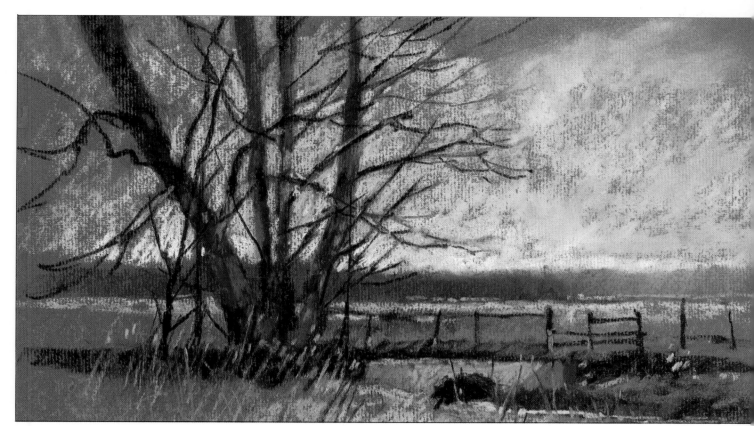

Fig. 104 *Near Dorchester* pastel

CLOSE-UP STUDIES

Different parts of a tree offer a never-ending source of subjects; such studies will increase your knowledge of trees considerably. Perhaps you have a friend who has a fruit tree in the garden and would not mind letting you have a small piece of branch in blossom. My acrylic painting of apple blossom (**fig. 105**) is painted on Bockingford watercolour paper. I put the branch in water and painted it in the studio, near a window.

After carefully considering the best angle from which to paint, I then studied the branch from all the other angles so that I was familiar with the parts I could not see. You should always adopt this method to familiarize yourself with the subject. With a 2B pencil I lightly roughed in the main parts, leaving out unnecessary detail. I wanted to get a feeling of life and growth into my painting, so I decided to use long flat hog oil colour brushes, Nos. 8, 6 and 3. I painted the branch

first, mixing the acrylic colours Burnt Umber and Burnt Sienna with very little White.

The leaves were quite a bright green, but I wanted a more subtle colour so I mixed Burnt Umber, Payne's Grey and Burnt Sienna with Bright Green. These warm colours modified the green to a deeper tone, which suited the subject. To add some vigour to the leaves I avoided defining the edges; the texture of the Bockingford paper suited the technique admirably. Next I painted the blossoms, mixing Crimson, Coeruleum (blue), Cadmium Yellow and White for the darker colours. For the lighter parts I used mostly White with a touch of Cadmium Yellow. The stamens are Burnt Sienna and Burnt Umber. I finished with a few touches of Payne's Grey and Burnt Sienna with White. When you paint or draw branches in leaf or blossom make sure the direction of growth looks natural.

Fig. 105

Fig. 106

Fig. 107

Fig. 108

Pine needles make an excellent subject for careful drawing. My sketch (**fig. 106**) is drawn with a 2B pencil on cartridge paper. I was particularly interested in the flowing shape of the needles.

My watercolour sketch (**fig. 107**) is a sprig of yew from the tree in our front garden. Some yew trees can live for about 1,000 years – in the churchyard opposite my house there is a giant yew which must be several centuries old.

The other watercolour is of a piece of weeping birch (**fig. 108**). You will remember I mentioned how the character of a tree is determined by its outline and silhouette, and you can see that this may also apply when you are painting close-up studies. For this reason I have not added much detail, as the overall shape is more important. The colours I used were Lemon Yellow, Cobalt Blue and Burnt Sienna on smooth card. My outline pencil sketch was drawn with a 2B pencil.

Fig. 109

The London plane is only one of the many trees bearing flowers and fruit which are fascinating in shape, texture and colour: others include the horse chestnut, mulberry, maple, pear, apple, cherry, hawthorn and magnolia. My sketch (**fig. 109**) shows the beautiful shape and colour of the plane tree fruit, and its spring leaves. My sketch is mixed media, using watercolour and acrylic on Bockingford watercolour paper and the colours I used were Scarlet Alizarin, Burnt Sienna, Yellow Ochre, Cadmium Yellow and Payne's Grey. To keep the painting fresh I was careful to apply the minimum of colour washes.

The *prunus amanogawa* flowers in our garden and I have selected just a few blossoms for my pastel painting on cartridge paper (**fig. 110**). A characteristic of this prunus is its vertical growth.

For my acrylic painting of the Californian redwood tree (**fig. 111**) I chose a close-up view of the crown of this magnificent giant which towers up to the sky. The colours I used were Crimson, Ultramarine, Burnt Sienna, Cadmium Yellow and Cadmium Red.

When you draw leaves similar to those illustrated here you need not draw the serrated edge too accurately – you can go for a broad effect as I have.

Fig. 110

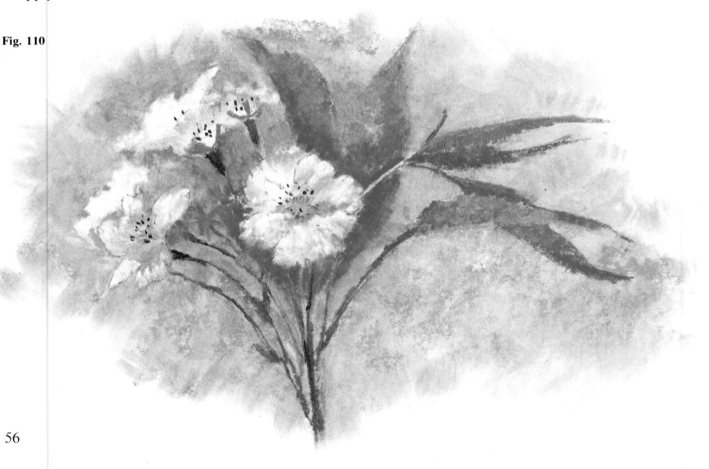

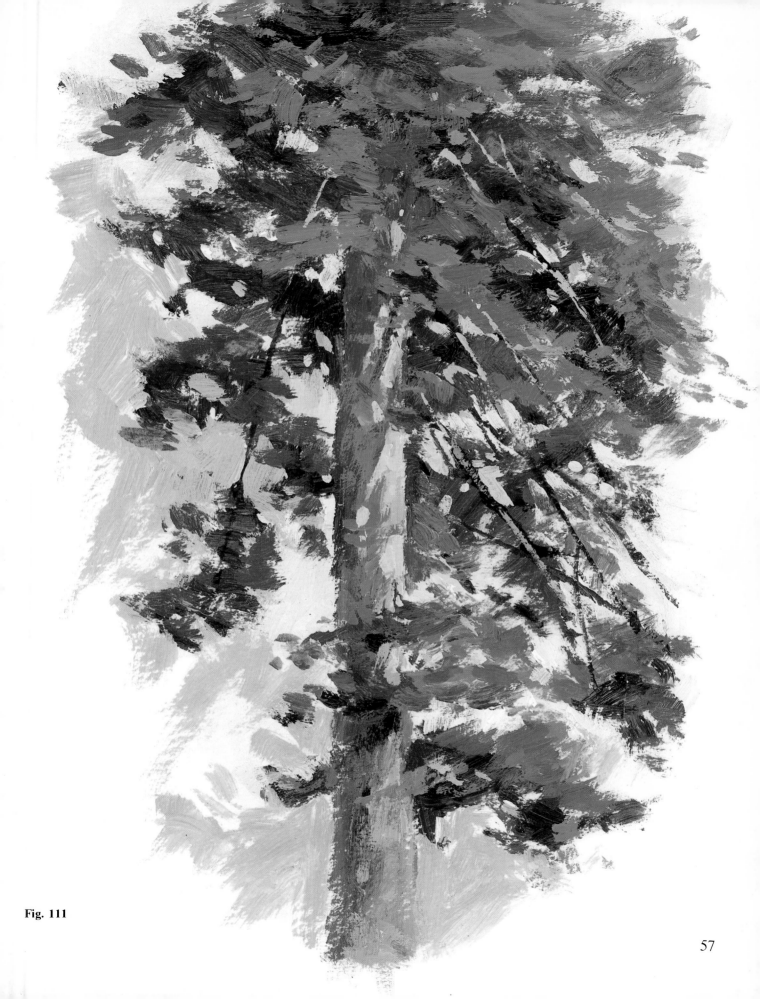

Fig. 111

GALLERY

To close, I have included in the following pages a portfolio of my landscape paintings. They confirm my particular interest in trying to capture the moods and atmosphere of nature. The paintings exemplify how trees can contribute to the success of a landscape painting, something which I have emphasized throughout the book. I consider this to be more important than learning merely how to paint a tree 'portrait'.

These paintings have all been created in the studio from my imagination and without the aid of photographic references. Being receptive to nature's moods and consistently painting and drawing outdoors has helped me reach the point where I can do this – something I hope you will eventually arrive at too after a fair amount of practice.

Writing this book has further impressed upon me how important it is to understand and paint trees well. Since I began to work on it, I have moved to north Dorset, and am now surrounded by an abundance of magnificent trees and views across miles of unspoilt countryside. I know it is the trees which will give me the greatest joy.

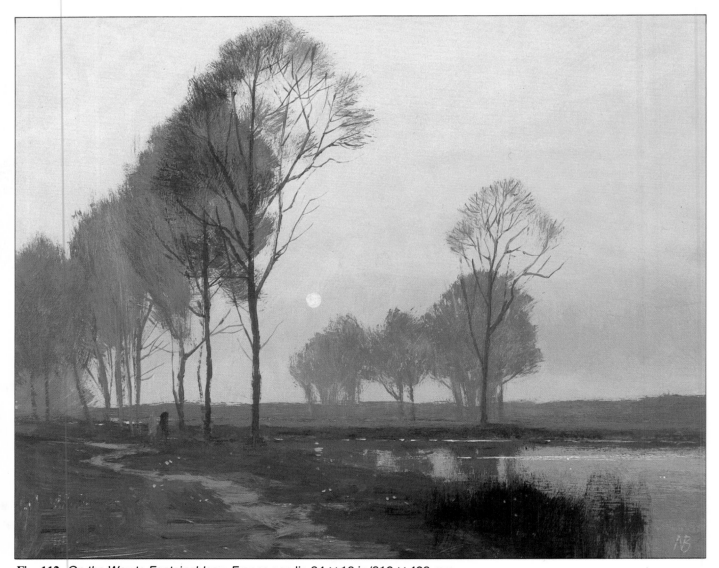

Fig. 112 *On the Way to Fontainebleau, France* acrylic 24 × 16 in/610 × 406 mm

58

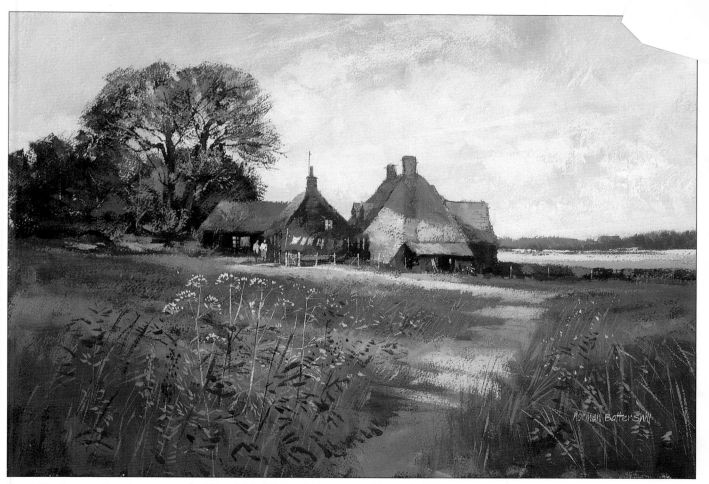

Fig. 113 *Sussex Farmhouse* acrylic 20 × 16 in/508 × 406 mm Fig. 114 *Winter Fields* oil 14 × 10 in/356 × 254 mm (below)

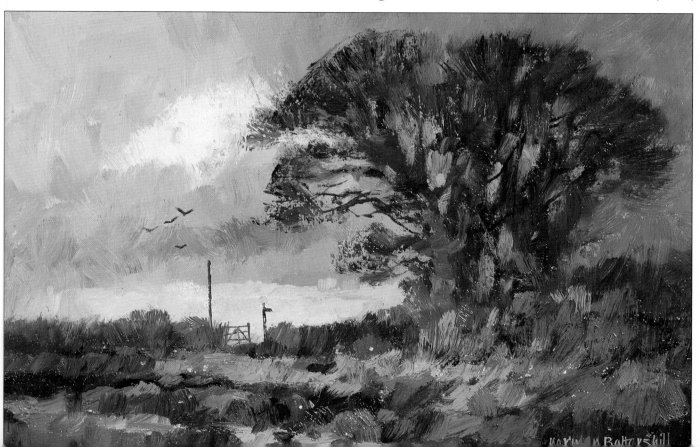

Fig. 115 *Sussex Landscape* charcoal actual size

60

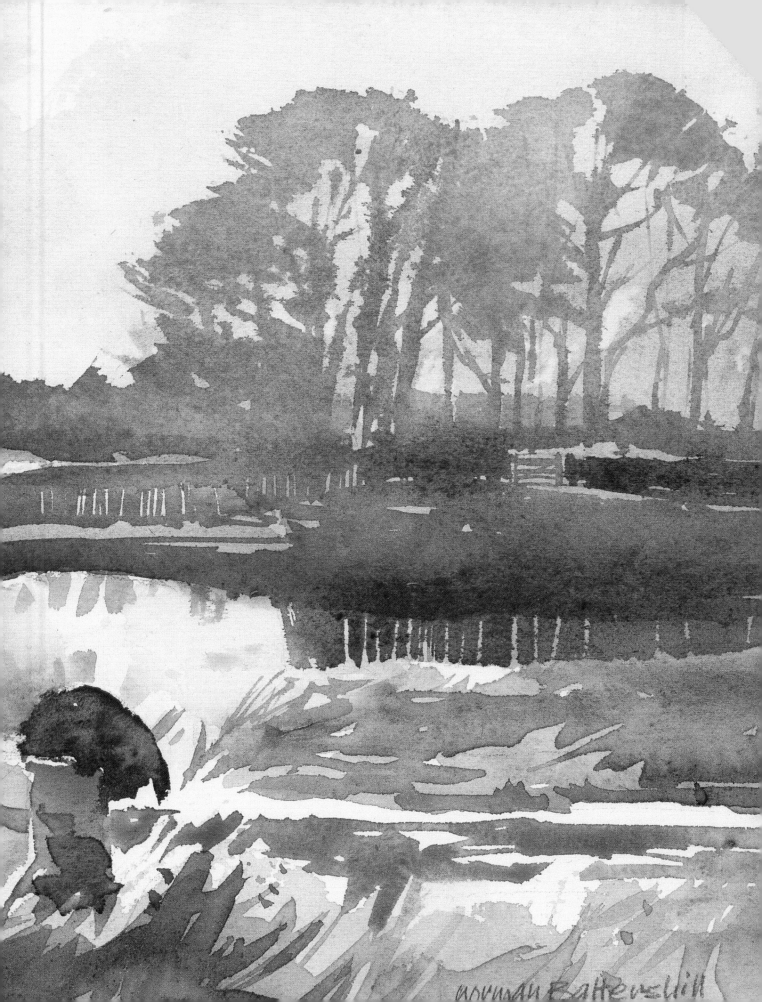

norman Battershill

Fig. 116 *Dorset Landscape* watercolour
12½ × 8½ in/
312 × 212 mm
(previous page)

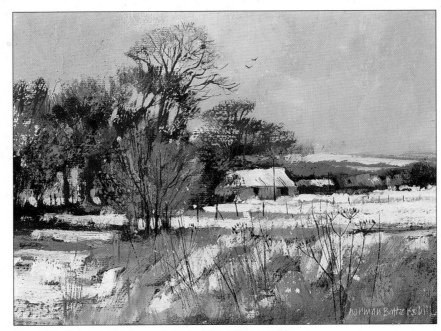

Fig. 117 *Snow in Sussex* oil 20 × 16 in/508 × 406 mm

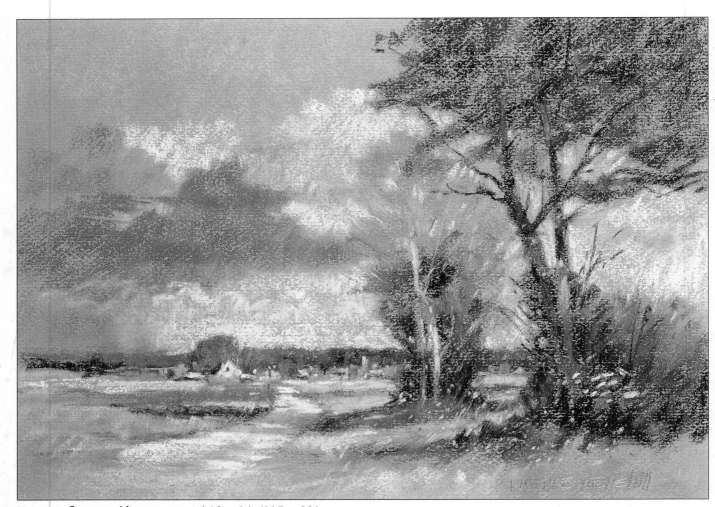

Fig. 118 *Summer Afternoon* pastel 12 × 9 in/305 × 229 mm